THE SIMPLE ART OF
SUMI-E

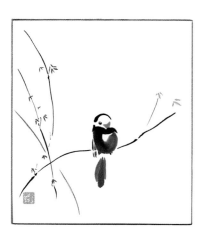

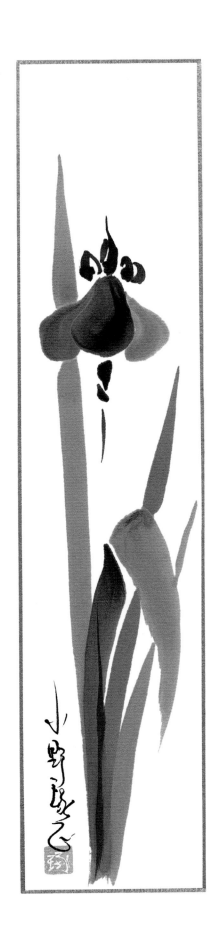

THE SIMPLE ART OF
SUMI-E

MASTERING JAPANESE INK PAINTING

TAKUMASA ONO

STERLING PUBLISHING CO., INC.
NEW YORK

First published in Great Britain in 2005 by Cico Books
32 Great Sutton Street London EC1V 0NB
Text © 2005 Takumasa Ono

Library of Congress Cataloging-in-Publication Data Available

10 9 8 7 6 5 4 3 2 1

Published in 2005 by Sterling Publishing Co., Inc.
387 Park Avenue South, New York, NY 10016
Copyright © 2005 Cico Books
Distributed in Canada by Sterling Publishing
c/o Canadian Manda Group, 165 Dufferin Street
Toronto, Ontario, Canada M6K 3H6

Manufactured in Singapore

Sterling ISBN 1-4027-2009-2

Translated by Yukiko Tagawa
Support and consulting by Chizuko Tokuno
Edited by Robin Gurdon
Photographs by Geoff Dann
Design by Ian Midson

Contents

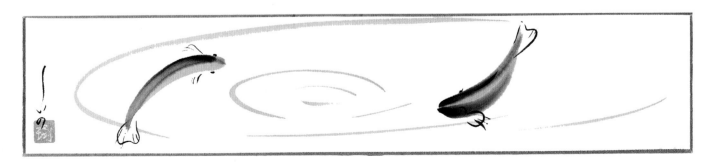

Introduction

Sumi-e instantly inspires me whenever I find myself in the midst of a beautiful Japanese landscape and decide to paint the scene before me. This style of Japanese ink painting, using only black ink, is the ideal way in which to depict the atmosphere and seasons of nature as I see them in my imagination. In order to express what is before me in black and white, first I purify the subject, and then I develop it in my mind, visualizing the bright colors. What is important is not to depict the subject as you see it, but to express your mind as well as the heart of nature.

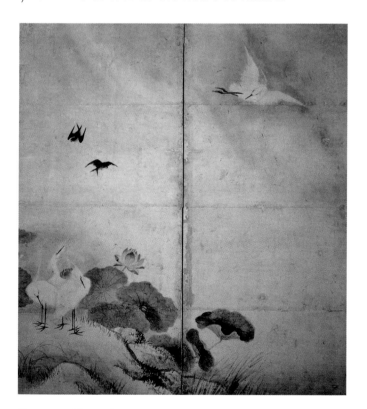

Flowers and Birds of the Four Seasons (Idemitsu Museum) by Noami.

Sumi-e is not just an important painting style because it uses only black ink—it is one of the arts nurtured in the climate so typical of Japan and in the esthetic feelings of the Japanese people following its arrival from China. The distinctive style and feel of sumi-e has been brought about by a combination of elements, such as the subtle differences of black color produced by the blending of sumi (the ink stick) and water; the line and surface expressed with various strokes of the brush; and the effect of the paper and silk on which the subject of the painting may be drawn. All these elements combine to create a unique harmony.

There are many great artworks in Japan which incorporate the esthetic values known as wabi (subtle taste) and sabi (elegant simplicity). They can be seen especially in the landscape painting of the great artists Noami (1397–1471) and Sesshu (1420–1506), who both florished during the Muromachi period (1392–1573)——see Noami's Flowers and Birds of the Four Seasons (1469; left) and Sesshu's Landscape: Inscription by the artist et al. (1495; right). It may be said that wabi and sabi encompass beauty, and are ultimately achieved by omission and deformation, or the combination of blank space on the paper to show distance and the shaping of objects to show perspective. Underlining

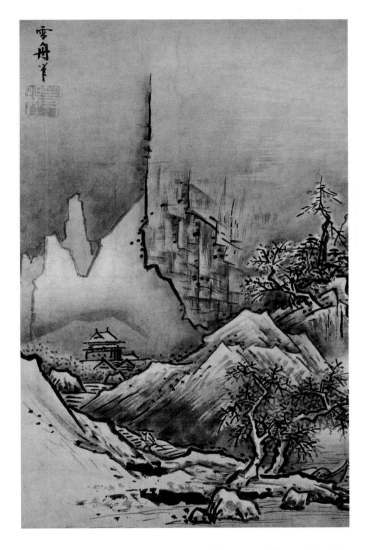

Landscape: Inscription by the Artist et al. *(Tokyo National Museum) Sesshu's work exemplifies the greatest* sumi-e *of the fifteenth-century Muromachi period.*

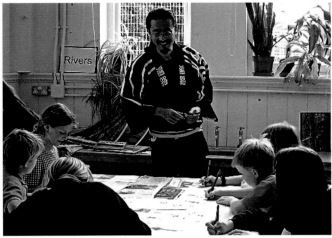

The author leads a sumi-e *workshop for a class of small children, each one beginning the fulfilling journey toward the mastery of the art.*

the essence of the subject, translating it onto paper while leaving out unnecessary details. In this way, *sumi-e* pursues simplicity. With its simple brush strokes and painting style, the *sumi-e* artist extracts the spirit of nature. It refuses to use colors, opting instead for black ink, but it is not simply black. Black represents infinite color with many different shades: the artist constructs a harmonious world with shade as if he were playing a musical instrument.

this are philosophical, literary, and religious elements which demand the esthetic feeling and profound wisdom of the artist. That is to say, that the artist's ideas and humanity are revealed through his work. One goal of classical Western painting, however, was to depict the subject as realistically as possible, and artists developed a technique of three-dimensional perspectives to achieve its goal. The goal of *sumi-e* is to capture

Whether you are good at painting or not, listen to your inner self, feeling the essence of nature with your heart and creating your world of movement and quietness, which is the spirit of *sumi-e*. Look at nature carefully, paint as many subjects in *sumi-e* as possible, and then you will understand the essence of nature. Some day, after painting much *sumi-e*, your art may surprise you and others with its own distinctive quality.

The History of Sumi-e

The art form of *sumi-e*, which dates back over more than one thousand years, has its roots in the imperial palaces of seventh-century China. The history of Chinese ink painting is obscure and it is difficult to determine its exact origin— opinion is even divided on what is considered ink painting. But it is generally believed to have begun during the Tang Dynasty (618–907A.D.), reaching its zenith during the the Song (960–1271) and Yuan (1271–1368) dynasties, while at the time slowly gaining influence in Korea and Japan.

Early Ink Painting in Japan: 12th to 13th Centuries

Ink painting is thought to have been fully assimilated into Japanese culture by the end of the Kamakura period at the start of the fourteenth century. Over the previous four centuries, through the Heian to Kamakura periods, many elements of Chinese culture had been brought to Japan by traveling Buddhist monks, including the painting style developed in the Song and Yuan dynasties. At the beginning of the Kamakura period in the twelfth century,

Josetsu's innovative **Catching a Catfish with a Gourd** *(Taizouin, Kyoto) was painted at the request of the Fourth Shogun, Ashikaga Yoshimochi (1386–1428).*

new Buddhist sects, particularly Zen, began to florish in Japan, and many temples were constructed. By the end of the period the influence of Zen culture dominated Japan, and ink painting based on the cultural and spiritual characteristics of Zen monasteries spread throughout monastic communities. Early ink painting in Japan took up Buddhist figures and mentors as their subjects.

The Birth of Japanese Sumi-e

The Muromachi period (1392–1573) which followed saw the monks who studied Chinese ink painting start to produce their own distinctive works, known for the first time as *sumi-e*. As the technique came to full maturity and subject matter expanded, *sumi-e* became more than a hobby or a teaching medium for monks, and consequently the professional monk painters appeared. At the Shokokuji monastery in Kyoto, a temple constructed by the shogunate (Japan's military rulers), the Zen monk Josetsu (1394–1428) is credited with establishing the style for *sumi-e* landscapes. The painting *Catching a Catfish with a Gourd* at the direct request of Japan's military ruler—the fourth Shogun, Ashikaga Yoshimochi—reveals only a glimpse of its Chinese influences, while the uniqueness of its theme, the soft touch of

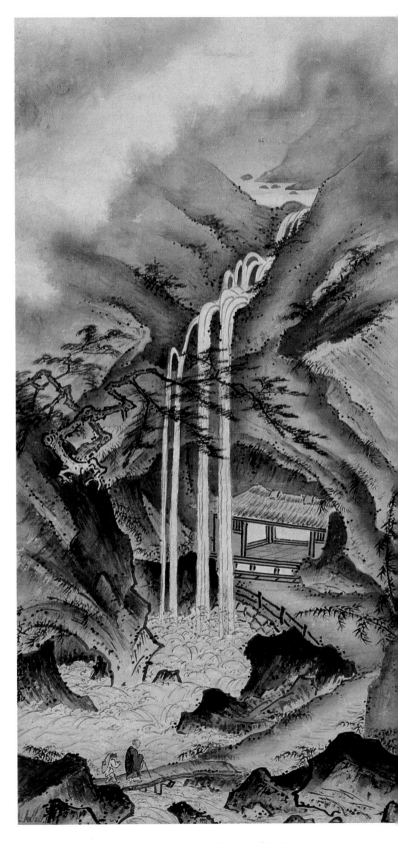

Geiami's Viewing Waterfall *(Nezu Institute of Fine Arts, Tokyo).*

the brush, and the use of extra water all imply the individuality of the Japanese *sumi-e* style.

Josetsu later taught *sumi-e* at the Shokokuji Temple. Pupils gathered around skilled painters, and master-pupil relationships became common. A distinctive Japanese painting style had been established and many of the great artists were born in the following period. Among these were Noami (1397–1471), Geiami (1431–85), and Soami (?–1525), three generations of the same family who all worked for the Ashikaga shoguns. Known together as the "San-ami," they were so well-regarded that they incorporated the Chinese character "ami" from Buddha's name, even though it was not strictly part of their names. They were curators of the Shogun's art collection, connoisseurs, interior designers, and consultants in all matters of art. They even composed linked verses and were key figures in the history of both the tea ceremony and traditional flower arrangement.

The success of the San-ami's careers indicate the importance that society came to attach to sensitivity and ideas rather than the pure techniques of painting. It was also during this era that prominent esthetes started both to design entirely artistic lifestyles and formalize the

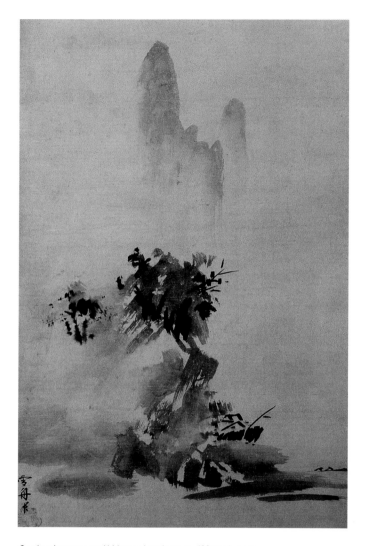

Sesshu: Autumn and Winter Landscapes *(fifteenth-century, Tokyo National Museum).*

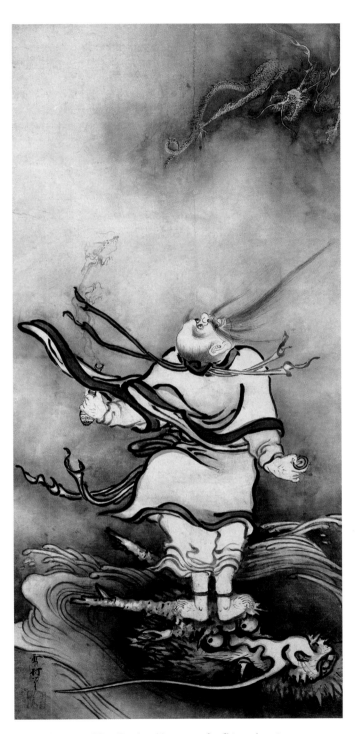

Sesson: Portrait of Ryo Douhin *(the name of a Chinese hermit, Yamatobunkakan Museum).*

apprentice system, which has passed down knowledge from master to student for generations and is still alive today.

While the San-ami were still working vigorously, the foremost master of *sumi-e* came to be Sesshu, who stamped his own individuality and character into the art of Japan. Sesshu (1420–1506), who was another Zen monk at the Shokokuji Temple in Kyoto, first studied ink painting under Shubun but also visited China, where he studied the styles of the Southern Song and Seppa schools. Having learned these various styles, he went on to perfect his own distinctive method of artistic expression, setting the standard in ink painting for later Japanese artists. His *Autumn and Winter Landscapes* attracts viewers with the strong lines and shapes which make up the painting. He includes a brilliant abstract interpretation of nature in his work.

Many painters beside Sesshu perfected the skills of *sumi-e* during the Muromachi period. Among them was Sesson, a monk of the Soto sect. He studied Sesshu's work and went on to develop a distinguished and individualistic style of his own. Sesson's paintings were the rich artistic representation of Japan's transition

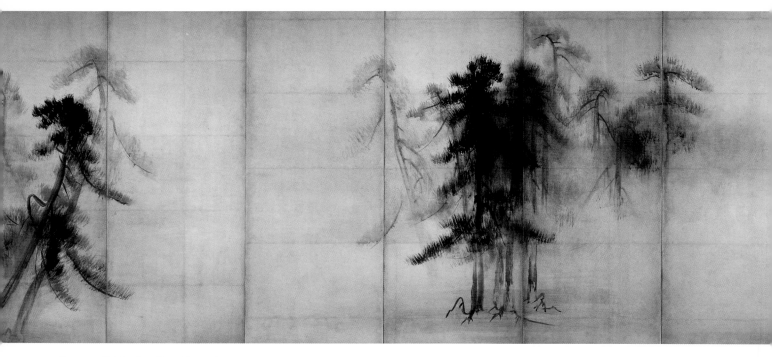

Hasegawa Tohaku: Pine Tree *(Tokyo National Museum).*

from a crumbling medieval country through the turbulent Momoyama period of the late sixteenth century, which marked the ending of almost a century of civil war. His *Portrait of Ryo Douhin* (a Chinese hermit; see page 11) with its unique choice of subject and strong, vivacious brush movements has left marks on all Japanese *sumi-e* painters since.

Hasegawa Tohaku was also one of the great artists of this period. His masterpiece, *Pine Tree, which is* held in the Tokyo National Museum (see above), is considered to be the most important ink painting in Japanese art history.

During the Azuchi-Momoyama period (1568–1600), many *shoheiga*, or screen and partition paintings, were produced to fill temples and the many castles constructed by the rival warlords who now controlled the country. To emphasize their new standing, they hired the most popular artists to decorate their castles, ensuring that much *sumi-e* was painted on these sliding doors and folding screens.

The Development of Distinctive Japanese Sumi-e

During the transition from the Azuchi-Momoyama to the more peaceful Edo period, the sixteenth-century painter Tawaraya Sotatsu

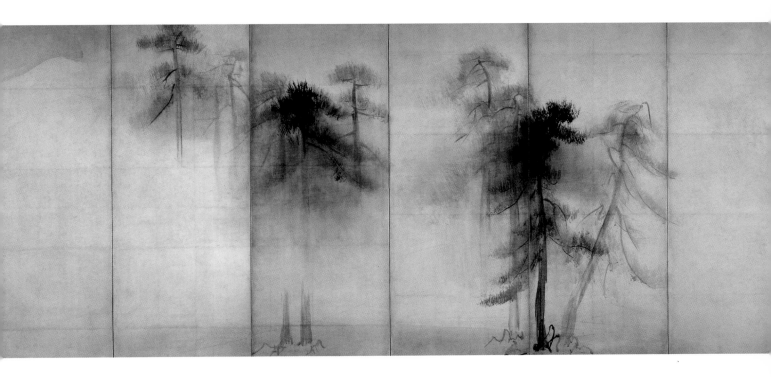

emerged, who forged a new and purely Japanese style of *sumi-e*. He is also credited with founding the decorative Rimpa school of Japanese painting and revived the *yamato-e* style by augmenting its lyric quality with brilliant colors and a bold graphic sense. His *sumi-e* was rooted in his native Japan and all traces of Chinese influence were eliminated in his work. He created rich, subtle ink effects with techniques that included *tarashikomi*, the dripping technique, which unlike accidental spills of ink, produces a magical effect on a painting. This, together with his original style of painting, has great influence over modern Japanese *sumi-e* (see *Water Fowl in the Lotus Pond*, page 14).

The Edo period (1603–1867) was a peaceful and socially stable age and an era in which the general public's taste became strongly reflected in national culture. Chinese ink painting had been reintroduced to Japan in the early seventeenth century, and Ike no Taiga (1723–76), Yosa Buson (1716–84) and Uragami Gyokudo (1745–1820) all studied the soft ink style of the Chinese Southern School, their paintings were described as *bunjinga* or *nanga*. Although they had studied and learned the Southern style, Japanese artists did not just follow the Chinese traditions but also included stylistic cues from the more academic Chinese Northern style. This smart and refined *sumi-e*

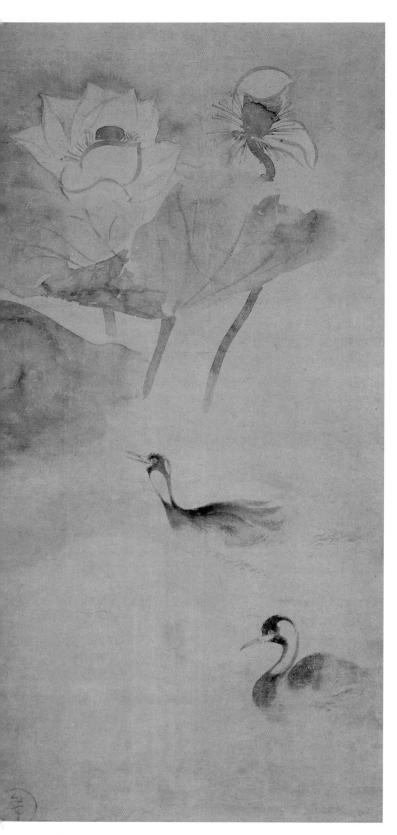

Tawaraya Sotatsu: Water Fowl in the Lotus Pond *(Kyoto National Museum).*

led to a new style of art called *haiga* which combined the calligraphy of *haiku* poetry with simple but precise brush painting. While the country's self-imposed seclusion from the outside world came to overshadow the Edo period, Japan was able to mature as a country and uniquely Japanese styles, including *ukiyo-e*—literally, "pictures from the floating world"—were born. Many robust and bold *sumi-e* works were produced, with *samurai* warriors and painters creating brilliant pieces. Among these was Miyamoto Musashi, whose work is loaded with tension as if he had painted with his sword rather than a brush, showing that *sumi-e* not only depicts the subject but also captures the spiritual world of the painter.

Another famous painter of this period was Maruyama Okyo (1733–95), who sketched from nature. Although not truly realist, he demonstrates his ability to build up scenery and use white space by depicting his subjects springing from an ornamentally designed world. Ito Jakuchu (see *Vegetable Nirvana*, right) also excelled in his realistic drawings of flowers, fish, and birds.

Although *sumi-e* has always had strong Chinese influences, Japanese painters have spent many centuries forging their own distinctive style, and *sumi-e*, which still requires only a few simple techniques, continues to thrive today.

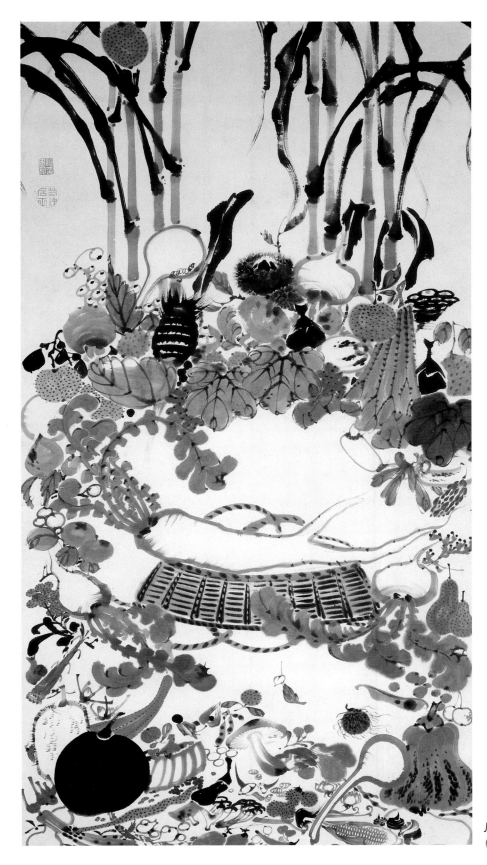

Jakuchu's masterpiece, Vegetable Nirvana
(Kyoto National Museum).

Materials

The basic materials you need to paint *sumi-e* are the "Four Treasures:" paper (*washi*), brushes (*fude*), an ink stone (*suzuri*), and an ink stick (*sumi*). Besides these, also have two or three dishes ready for the ink, a felt backing pad for the paper, a water container for rinsing brushes or adding water to the ink stone and, importantly, a rag, both to wipe the brush and to try out *sumi* shades. Before you start to paint, set up your table by placing all the necessary materials within easy reach.

Although I have used Japanese materials here, feel free to replace them with Chinese equivalents if they are unavailable.

Paper—*Washi*

Shiki-shi

Chiku-shi

Uruwashi,
*Japanese
lacquered paper*

Sumi-e paper can be broadly divided into three types according to its absorbency. *Gasen-shi* is the most absorbent, and easiest for the beginner to use. The group of *hosho-shi*, *ma-shi* and *kozo-shi* each blurs a little, and *torinoko-shi* is difficult to paint on as it is almost completely nonabsorbent.

Gasen-shi responds to ink quickly and gives the *sumi* a lively color. Because of its thinness, brush strokes remain visible on the page and it can tear easily when wet. An alternative is dual-layered *gasen-shi*, which is easier to handle though less absorbent, and the subtle differences of *sumi* color become dulled. Experiment with different types to find the one that you like and can most easily work on.

Ma-shi is considered to be the oldest paper in Japan introduced from China. It is made from hemp. It absorbs water well, shows the color of *sumi* ink the best and takes ink well. *Ma-shi* also allows overdrawing, without leaving behind traces of the brush strokes.

The third main paper type, *torinoko-shi*, has a smooth, hard and shiny surface. It is nonabsorbent so not obviously suitable for *sumi*-e painting, but can produce interesting results.

Shiki-shi is made from handmade art paper laminated to a hard board backing. They are edged with a strip of gold paper and are traditionally used for *sumi* painting, *haiku*, and watercolor painting.

*Hand-made
washi postcards*

*Fan-shaped
torinoko-shi*

Ganpi-shi

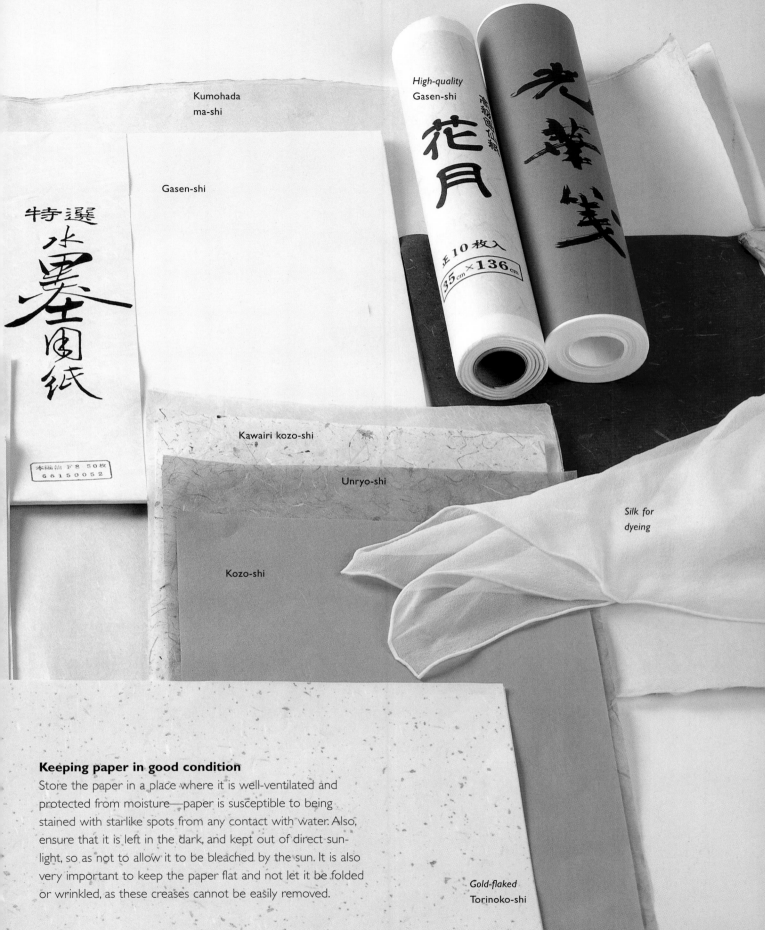

Kumohada
ma-shi

Gasen-shi

特選
水墨
画
用
紙

本画仙 F8 50枚
66150052

High-quality
Gasen-shi

花月

正10枚入

35cm×136cm

光華箋

Kawairi kozo-shi

Unryo-shi

Kozo-shi

*Silk for
dyeing*

Keeping paper in good condition

Store the paper in a place where it is well-ventilated and protected from moisture—paper is susceptible to being stained with starlike spots from any contact with water. Also, ensure that it is left in the dark, and kept out of direct sunlight, so as not to allow it to be bleached by the sun. It is also very important to keep the paper flat and not let it be folded or wrinkled, as these creases cannot be easily removed.

Gold-flaked
Torinoko-shi

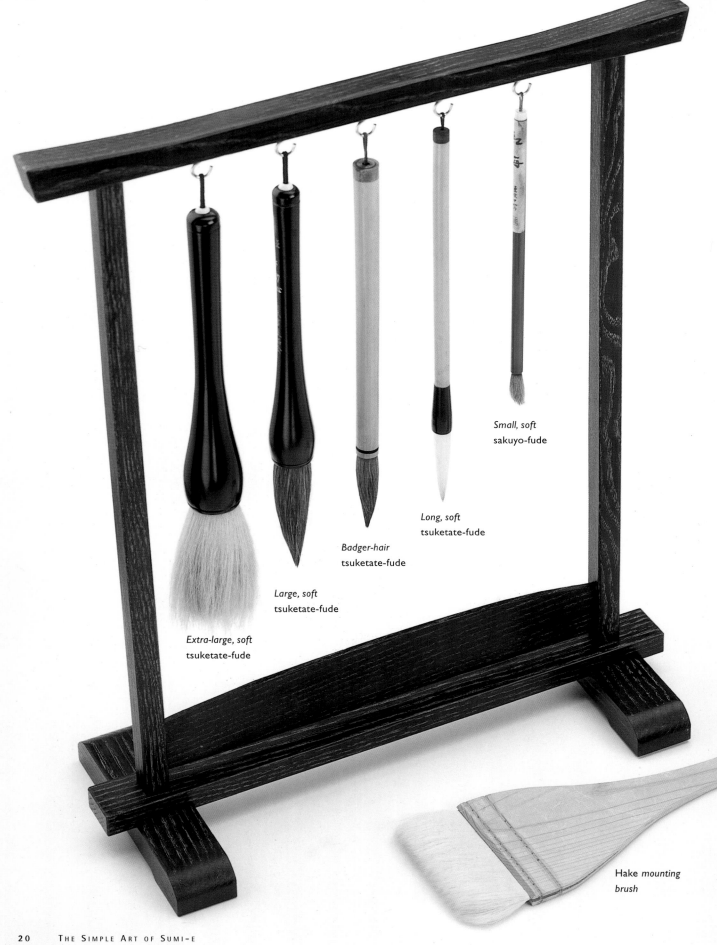

Small, soft
sakuyo-fude

Long, soft
tsuketate-fude

Badger-hair
tsuketate-fude

Large, soft
tsuketate-fude

Extra-large, soft
tsuketate-fude

Hake *mounting brush*

Brushes—*Fude*

The art of *sumi-e* is characterized by a freedom of movement in its brushstrokes. It is important to use brushes that give you a wide range of expression. Made from the hair of animals such as deer, rabbit, and sheep, there are three basic types:

The *tsuketate-fude* is the most common *sumi-e* brush, allowing you to write as well as paint. It should have long, hard hair in its core—to allow the brush to flex and bounce as it is twisted while also retaining strength—surrounded by hair of an equal length. Begin with the middle size.

The *sakuyo-fude* is used for line drawing, but it can also draw thick lines. Well-suited to line drawings, such as for flowers, there are two types of this brush; one gives a hard and thick line, while the other allows you to draw a soft line.

The *menso-fude* is a fine brush used for fine line drawings, painting details or small areas like cards. The badger-hair version is said to be the best brush available.

The *hake*, or paintbrush, is used to lay large areas of water or ink for blurring. It is also used to apply the paste and remove air bubbles when you mount a finished painting on paper.

When using a brush for the first time, dip it in cold water to remove the coating of glue (soap is unnecessary). Drain off the water and gently shape the tip of the brush by hand. After use, wash it and wipe any excess water off with a rag. Let it dry by hanging with the bristles downward or by laying it flat. Never place a cap over the brush's bristles. Instead, store it in a place that is well-ventilated and dust-free.

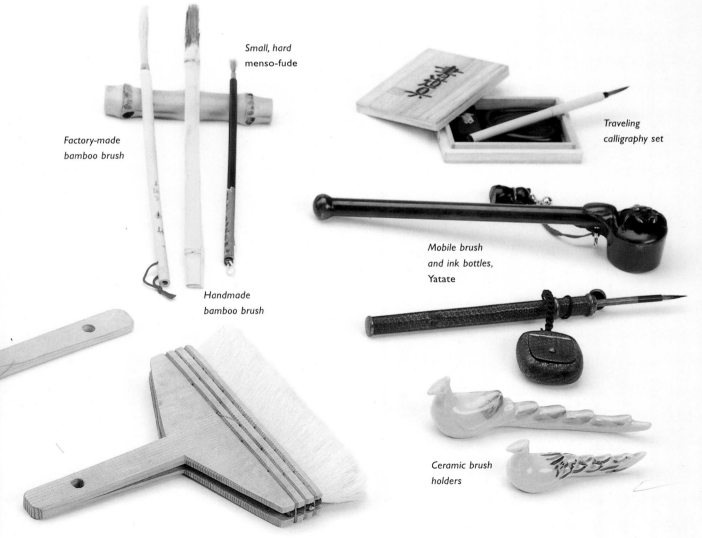

Small, hard menso-fude

Factory-made bamboo brush

Handmade bamboo brush

Traveling calligraphy set

Mobile brush and ink bottles, Yatate

Ceramic brush holders

Ink Sticks and Ink Stones—
Sumi and *Suzuri*

Sumi—Ink

The world of *sumi-e* is distinguished by the rich nuances and brilliance of the shades of black *sumi* ink. Whether you use the lightest ink first and then add the medium and dark ink, or begin with the dark shade first before adding water or light ink, the beauty of *sumi-e* depends on the range of colors within the ink. Choose the *sumi* stick which enables you to produce elegant color. The color of a *sumi* stick can be best discovered when you make a light ink.

There are two distinctly Japanese types of *sumi* stick, namely *shoenboku* (blue ink stick) and *yuenboku* (brown ink stick)— both are very different from those imported from China. *Shoenboku* is made from the soot of burnt pine, molded into a hard *sumi* stick with a binding agent. The color of this ink has a blue tone. *Yuenboku* is made from the soot of burnt vegetable oils, such as rape oil. The color of this ink has a slightly brown tone.

Japanese *sumi* sticks use glue made from animal skin and bone as the binding agent, while Chinese sticks use fish glue. Japanese sticks also have a strong adhesive power which is best used on *washi* paper. The binding power of Chinese *sumi* sticks is best suited to the softer Chinese papers.

Always leave an ink stick to dry at room temperature after it has been used. As ink sticks are sensitive, overheating or chilling can mean they dry out, become brittle, or even burst.

Suzuri—Ink stone

There are Chinese ink stones as well as Japanese stones, and these too vary. The best stones feel as smooth and soft to the touch as the skin of a young child, and, like a child, they will seem to cling as you grind the *sumi* stick.

The stone must always be cleaned under water or wiped off with a rag or a piece of paper after it has been used. Make sure that all ink particles are removed. Because of the fat content of the *sumi*, any ink left on the stone will become hard and stick to the stone so that the next time you grind the *sumi* stick, it will mix with the dregs. After it has been cleaned with water, dry the stone well and keep it where it won't gather dust.

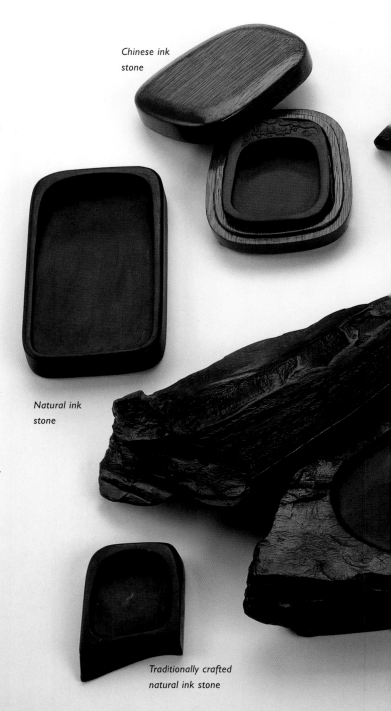

Chinese ink stone

Natural ink stone

Traditionally crafted natural ink stone

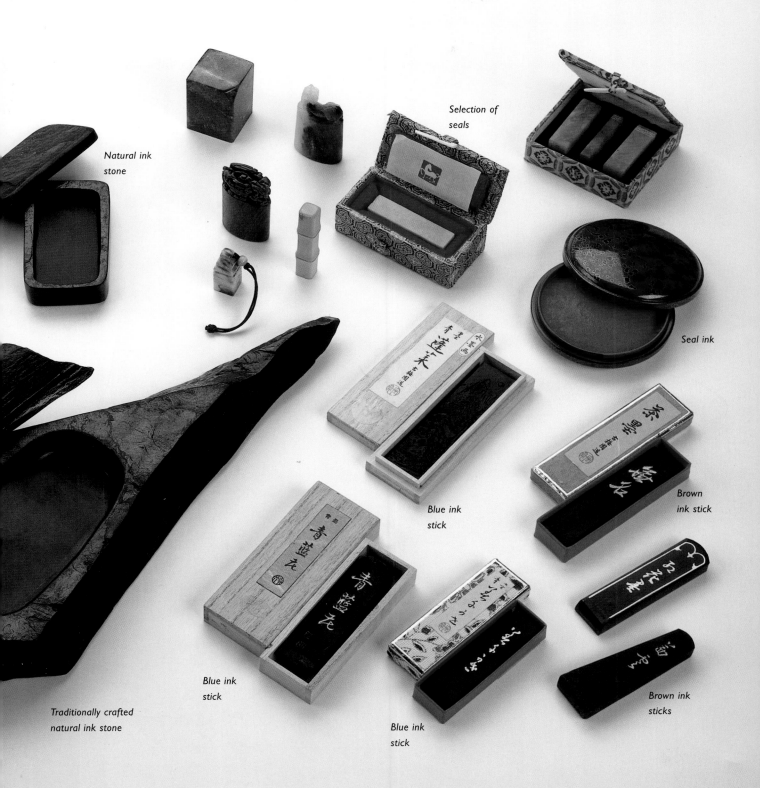

Natural ink stone

Selection of seals

Seal ink

Traditionally crafted
natural ink stone

Blue ink
stick

Blue ink
stick

Brown
ink stick

Blue ink
stick

Brown ink
sticks

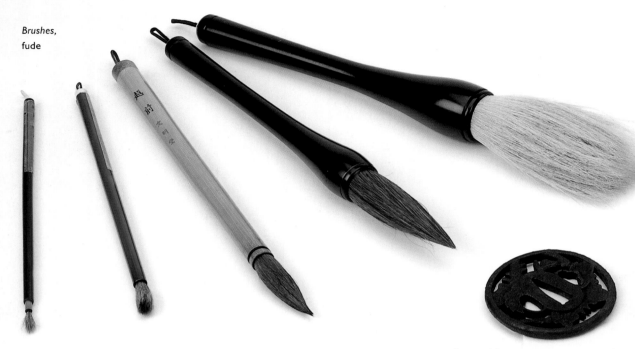

Brushes,
fude

Paperweight

Gasen-shi practice
paper

Washi

Seals

Seal ink

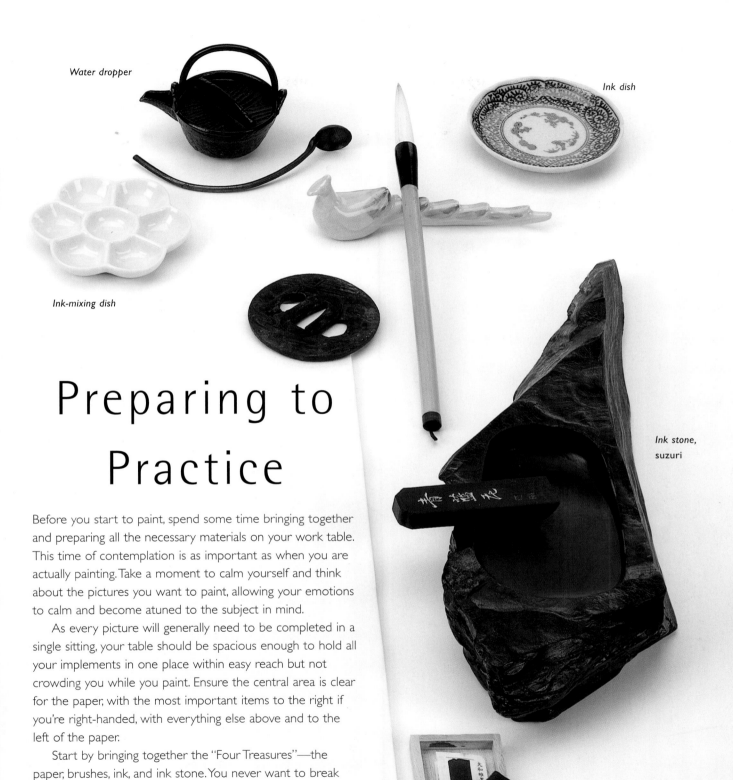

Water dropper

Ink dish

Ink-mixing dish

Ink stone, suzuri

Preparing to Practice

Before you start to paint, spend some time bringing together and preparing all the necessary materials on your work table. This time of contemplation is as important as when you are actually painting. Take a moment to calm yourself and think about the pictures you want to paint, allowing your emotions to calm and become atuned to the subject in mind.

As every picture will generally need to be completed in a single sitting, your table should be spacious enough to hold all your implements in one place within easy reach but not crowding you while you paint. Ensure the central area is clear for the paper, with the most important items to the right if you're right-handed, with everything else above and to the left of the paper.

Start by bringing together the "Four Treasures"—the paper, brushes, ink, and ink stone. You never want to break your concentration by moving away from the table to find another brush or refill your water bowl so prepare everything in advance. With the paper held by paperweights on a writing mat at the center, place your brushes, ink, water, seal, and seal ink around it within easy reach.

Ink, sumi

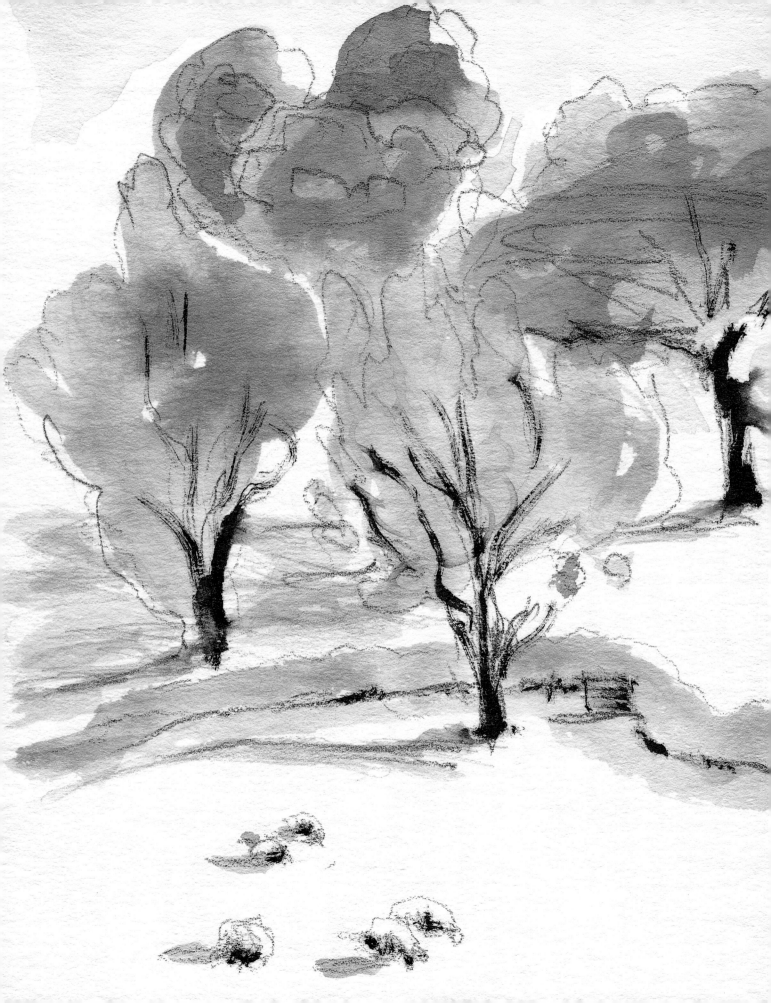

Techniques

Before starting to paint *sumi-e*, it is important to discover both the art's basic techniques as well as the philosophy on which it is based.

The most elegant *sumi-e* is created simply through the contrasting use of black and white colors—the black of the ink and the white of the paper. The teachings of Zen philosophy underpin this simple contrast: balance the teaching of *mu*, or "no self," which puts aside all worldly desire, with your ability to fill your painting with as much of the spirit of Zen, known as *satori*, as possible. While working, always ask yourself if you could be any more full of spirit, and maintain this reflective attitude as you paint.

Combine this with the simple techniques of creating shade and the drawing of lines, and you will find that this is all you need to start creating every sort of *sumi-e*.

Mixing Ink

Sumi-e is an art form created from the harmony of paper, *sumi*, and water. It is characterized by the sharp contrast between the black *sumi* ink and white paper, coupled with the gradation of ink. Not only is all the color, light, and shadow of the natural world depicted through the single tone of *sumi* ink, but the world of painting is illustrated too. It may be said that the art of *sumi-e* is completely dependent upon the color of *sumi* ink. Unlike western painting, the procedure of *sumi-e* starts with the preparation of the ink. Just as you do when you physically paint *sumi-e*, channel all the strength of your mind into grinding the *sumi* against the ink stone, holding the heart of Zen, *mu*, until you have captured the ideal consistency, color, and strength of ink.

Mixing Tips

Always ensure that you grind the ink stick with a little water in an even, circular motion on the flat part or "land" of the stone until the ink is thick and black. Also, before you begin painting, prepare medium and light shades of ink in separate bowls by mixing a few small brushfuls of dark ink with water, testing each tone out on practice paper.

When loading the brush with *sumi* ink, it is important to utilize all the absorption of the brush hair. Hold the brush in an upright position and dip it in the deepest part of the ink stone, the "ocean" (see step 3). Let the brush draw in the ink, and then gently lift the brush away from the stone. Do not draw ink onto an angled brush as the ink on the brush will just be pulled back to the pool of ink in the "ocean" of the stone.

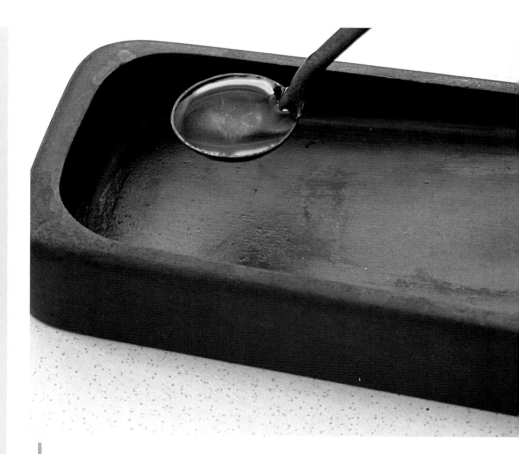

I On a clean ink stone, or *suzuri*, pour a few drops of fresh water, the amount depending on the size of the ink stone you are using. If too much water is lying in the deep part, or "ocean," of the ink stone in which you grind the *sumi* stick, the result will be cloudy, rather than a smooth, beautiful ink.

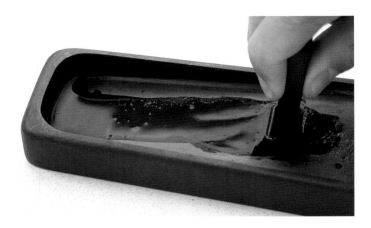

2 Grind the *sumi* stick gently on the flat part, or the "land," of the ink stone, gently drawing a big circle without applying too much pressure. If you grind with strength, the color of the *sumi* will be dull. When your ink is thick and creamy, push this ink into the ocean and then add some more water on the land. Continue grinding in order to make the blackest and most highly concentrated ink.

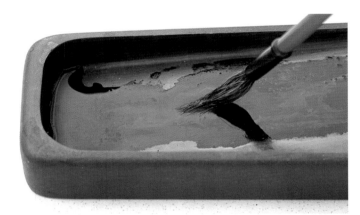

3 Wash the brush and drain off the water to make it easy for the brush to draw up the ink. Put the brush tip gently onto the ink stone. Let the ink draw up slowly from the tip of the brush. Depending on what you are painting and the quality of the paper, the amount you need differs.

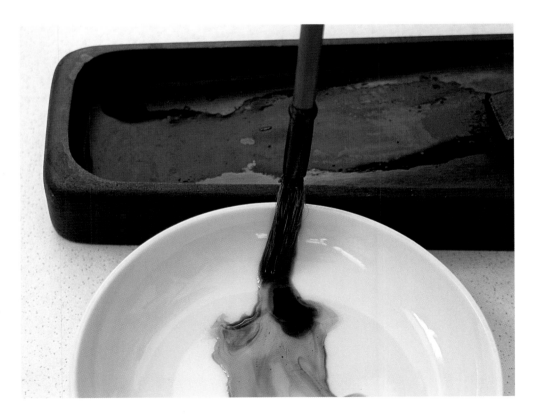

4 Adjust the shade of the *sumi* by transferring the ink onto a small plate—you should never try to adjust the color on the paper while painting. Prepare quantities of the desired shades on separate plates beforehand and paint with these. To paint a beautiful gradation with a single stroke, patiently adjust the color to create the desired color effect.

Holding the Brush

The *sumi-e* brush is the tool that allows you to express your emotions directly onto paper. Sit in a comfortable position that will enable you to move the brush swiftly and freely over the entire surface of the paper, and hold the stalk of the brush lightly. It is important to imagine that your hand is a tool of your mind, just like a branch of a tree growing from the trunk. Made from the natural hair of animals, the *sumi-e* brush has a great capacity for holding ink. In conjunction with the absorbency of the paper, the hair of the brush tip transfers the ink cleanly onto the surface. Hold the brush lightly and concentrate on the shape you want to paint. Next, allow your brush to paint what you have imagined, adjusting the amount of *sumi* ink and controlling the speed of movement of your brush to create the form.

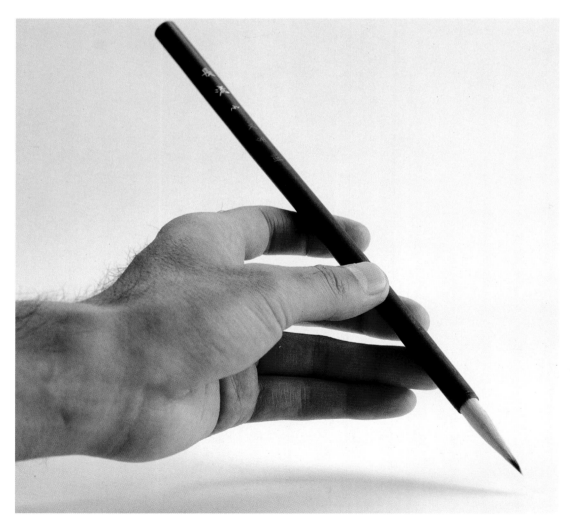

Slanted brush

For normal work, delicately hold a slanted brush using the soko grip (also known as sokohitsu-ho). This places the fingertips of forefinger and middle finger on the brush stalk, two-thirds of the way down, opposite the thumb. To allow you to move your hand and the brush freely in any direction keep your arm level, in what is known as the kenwan-ho position, with your elbow out, letting neither the elbow nor wrist touch the table.

Upright brush

To draw large images hold the brush with the soko grip again— using the thumb, forefinger and middle finger—but angle your hand over until the brush is vertical, known as chokuhitsu-ho. To pick up the brush, place it in the palm of your hand and let it roll onto your fingertips while you turn your hand over. Hold it lightly, keeping your arm straight but leave your whole body free to move. If you hold the brush too tight, free movement will not be possible.

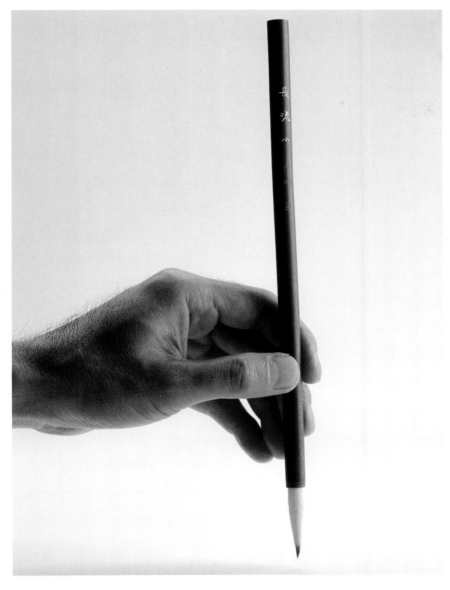

Delicate work

The tanko grip uses only the thumb and forefinger to hold the brush, letting your ring and little fingers lightly touch the paper to delicately control the pressure applied on the brush, which creates different shapes and shades— especially useful for painting small images. Again turn your hand over so that the brush is in the the upright, chokuhitsu-ho position.

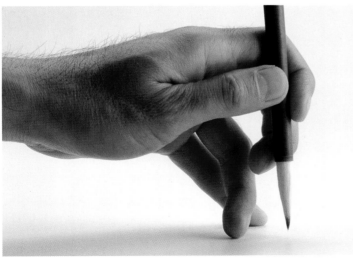

The Strokes:
The Rhythm of the Line

Sumi-e is an art of both mind and body. Using nothing more than the color of *sumi*, and a limited number of brush strokes, it renders the shapes and tones of an image. The way *sumi* combines with the paper ensures that redrawing is impossible so you have to devote heart and soul to every stroke you make. Concentrate hard, and know in your mind exactly what you want to paint before starting so that, by the time you take the brush in your hand, it should be guiding you. For this to happen, it is important to practice the brush strokes and learn how to control your mind and breath.

Combining tones

Although much of the philosophy and technique of *sumi-e* is based on simplicity, its brush strokes can be complex and eloquent. An alternative to loading the brush with a single shade of ink (see page 29), is to use the *sanboku-ho*, or "three *sumi* ink technique," to combine a selection of dark, medium, and light ink tones in a single brush stroke. First, prepare different shades of ink in separate dishes.

Then, clean your brush by rinsing it in clear water before taking any excess moisture off with a towel. Dip one side of the brush into the medium ink before applying a small drop of dark ink to the tip. You can choose any combination of inks: the tonal gradation depends on the amount of dark ink you add to the tip, the angle of the brush and pressure on the tip.

Practicing Lines

Use the two basic brush positions— *sokuhitsu-ho* created with a slanted brush, and *chokuhitsu-ho*, the upright brush—to experiment drawing every type of line. Start with the one shown to the right, in which the brush is pushed away from you. Then try moving the brush sideways, from left to right, or right to left. The goal is to practice drawing straight shapes and lines in different directions. The images opposite are variations of curved lines intended to depict leaves. They are all drawn with an upright brush.

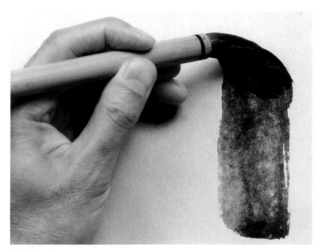

Thick lines
Draw a thick line using a slanted brush. Charge the brush with three different shades of ink—sanboku-ho. As the brush is pushed away, the shades separate to create the tone.

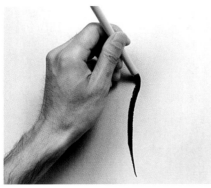

Practice lines: Exercise
This curved line is created with an upright brush—*chokuhitsu-ho*. The goal is to draw with a swift movement.

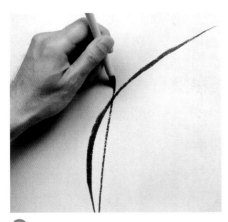

2 Experiment using different strengths and speeds, and see the different kinds of hard and soft lines that are created.

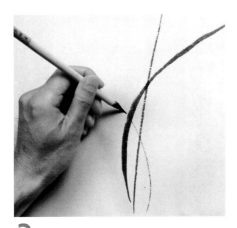

3 Use the light ink to draw the most delicate leaves. Hold your breath while pulling the brush in a left curving line.

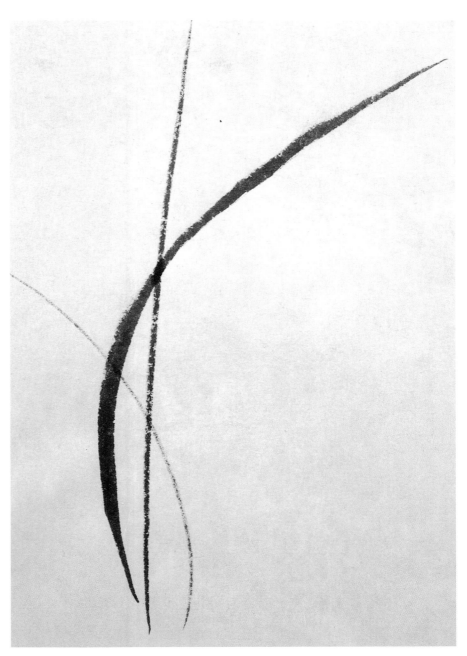

Creating Round Strokes

Round circles—known as *Enso*—are an abstract painting style expressing the symbol of enlightenment in Zen. A circle is the reflection of eternity; it has no beginning and no end. What is most important in drawing a circle is to focus your mind strongly so that you work without hesitating. Hold a concrete image of what you are going to draw and which brush strokes to use, so you can draw a beautiful circle. It is important to learn how to maintain tranquility of mind and breathing. Practice many times until you can draw a powerful circle.

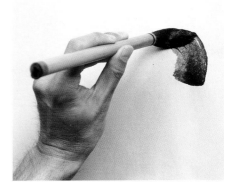

I Version 1:
Circle with varied tones

Using a slanted brush held in the *soko* grip (see page 30), start with all the bristles lightly touching the paper.

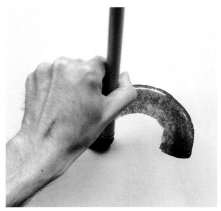

2 Use the wrist to turn the shaft of the brush, always keeping the brush tip to the circle's outer edge.

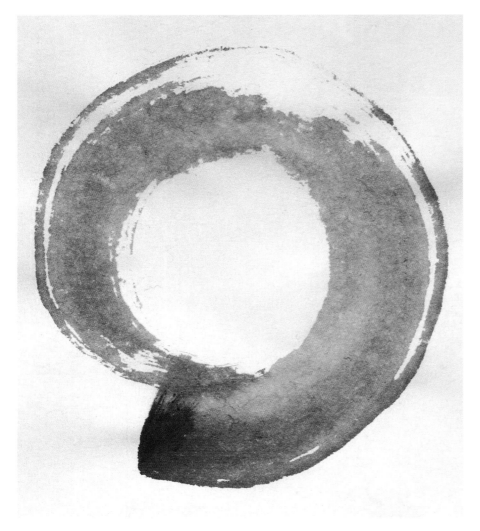

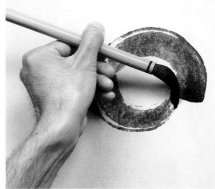

3 Keep an upright posture but relax. Keep both pressure and movement to a minimum throughout your painting.

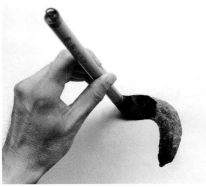

Version 2:
Circle with single tone

Take a brushful of ink. Drop the brush down to the paper with the brush tip in the center of the line and start drawing.

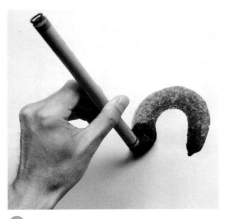

2 Holding the brush upright, keep the brush tip in the center of the line as you slowly rotate the brush.

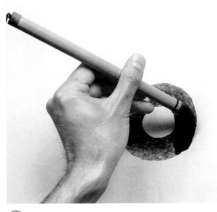

3 Try to apply constant pressure on the brush so that the ink lasts until you finish painting.

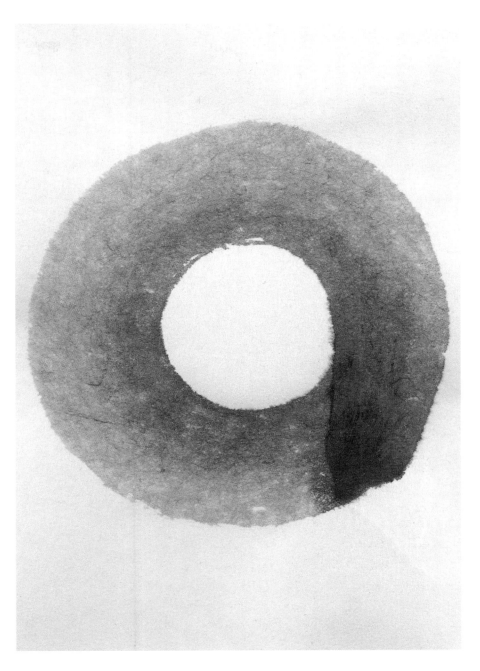

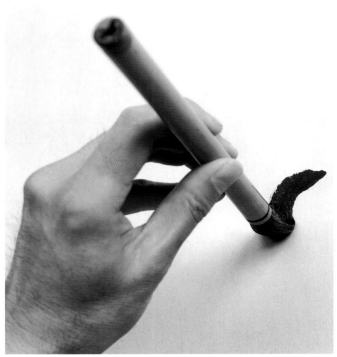

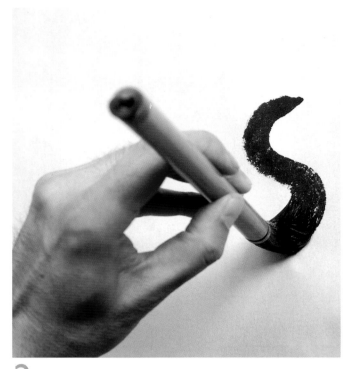

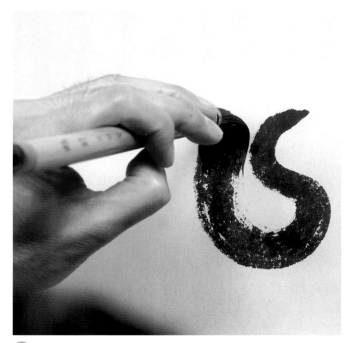

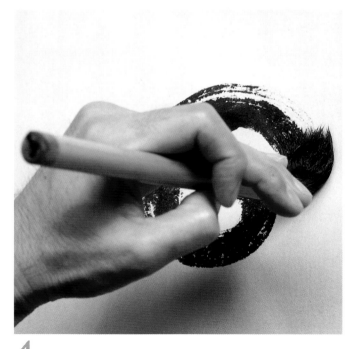

I *Futatsu-domoe—Yin yang circle*
Take a brushful of ink. First, draw a small circle as you move the brush, held in an upright brush position. Keep the brush tip at the center of the line.

2 Make a small curve as you draw an "S." As you near the lower part, pull the brush down into a slant, shifting the tip from the center to the outer contour of the circle.

3 Continue drawing the periphery of the circle in one swift stroke. Focus yourself in your painting.

4 Keep pressing all the bristles down onto the paper, with the handle leaning backward. Do not worry about creating a scratchy line.

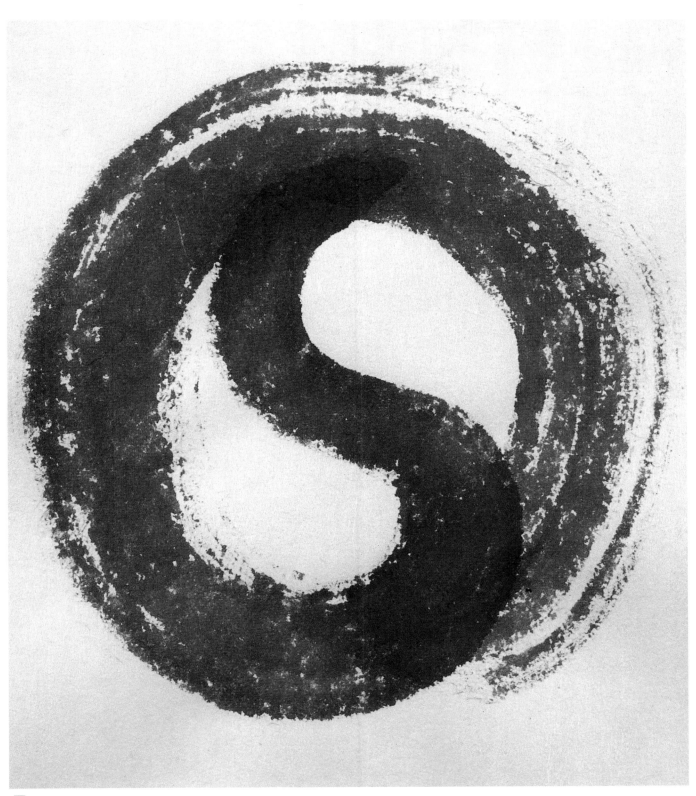

5 The scratchy texture of the latter part of the circle is
made as the brush dries, in a long and robust stroke named
kappitsu-ho. This stroke is ideal for drawing rocks or even animals.

Creating Dots Using a Wet Brush

The *junpitsu-ho*—wet brush—technique takes a brushful of water to create an effect of pooled ink with softly blurred edges, making the most of the *washi* paper. Unlike other brush strokes, the effect depends on the thickness and absorbency of the paper. It has a degree of chance, but it enables you to show a gradation of shading. Especially powerful and swift expressions of this dot is a technique frequently used by the masters of modern Japanese calligraphy.

The absorbency rate is never constant, depending on the paper, the amount of water contained in the brush, and the characteristics and amount of *sumi*. You can learn those characteristics through practice.

Splattered dot

Shake the ink loaded on the brush onto the paper from above without letting the tip touch the paper, just as you would sprinkle water, using a slight flick of the wrist.

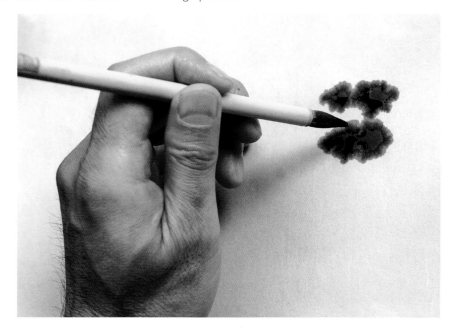

When dry, each splattered dot spreads out into a series of different tones.

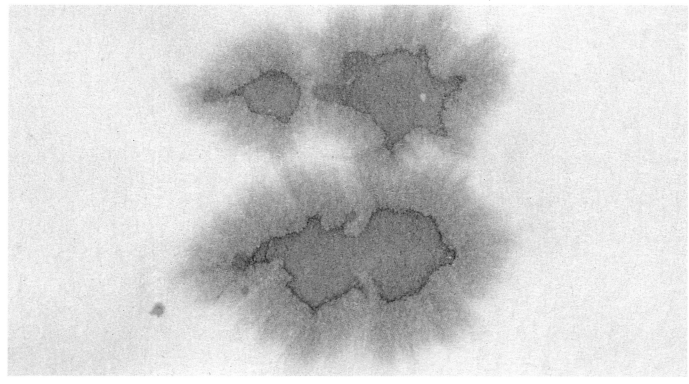

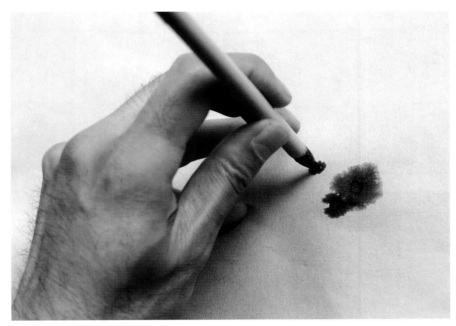

Placed dot
Hold the brush in an upright position and let the brush touch the paper, allowing it to absorb the ink. The dot can be as big as you like depending on the amount of ink loaded on the brush.

Painting a placed dot gives a far more controlled result that can be used when painting landscapes or animals.

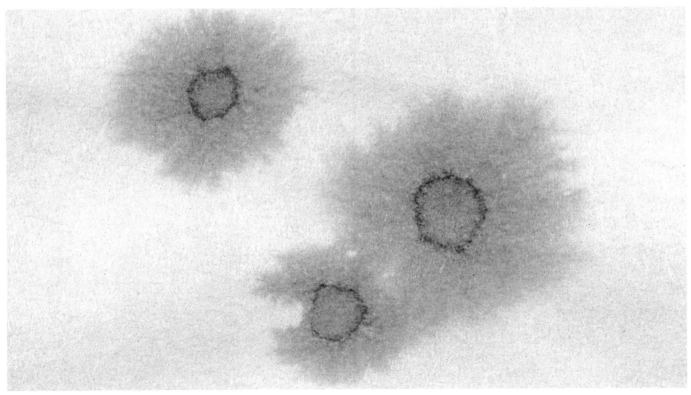

Creating Lines: The Soul of Ink

In painting *sumi-e*, it is fundamental to learn how to draw lines of different shades, to create width, or a straight line in a single stroke. The art of *sumi-e* lies in the subtlety and shade of the lines you create, which should reflect your inner feelings. Straighten yourself and concentrate on what you want to paint while you grind your *sumi*. If you hesitate during the stroke, the ink that is loaded on the brush may not last for the entire stroke, or your painting may look shaky and unsure. Practice will teach you the perfect combination of water and ink to load on the brush for each type of stroke.

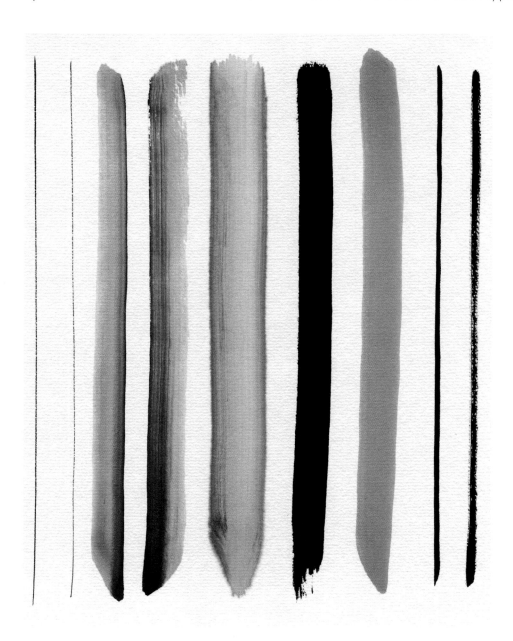

Simple Lines

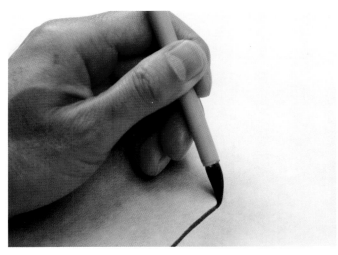

1. Basic line

The simplest line is of even tone and width, and is ideal for defining the outline of any object you wish to paint. This technique is called hakubyo-ho. Dip a sakuyo-fude brush in water before applying ink to the tip. Hold the brush at an angle using the soko grip (see page 30) and draw a thick line of even tone, pressing the bottom of the tip down to the side.

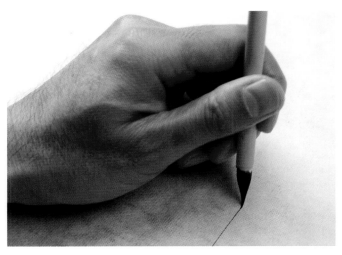

2. Fine line

To draw an outline with a very thin stroke, use another form of hakubyo-ho: wet the sakuyo-fude before applying ink to the tip, but hold the brush upright using the tanko grip in the chokuhitsu-ho position (see page 31). This ensures that only the very ends of the bristles touch the paper. Concentrate on the position of your fingers and that of your whole body. Rest your little finger on the paper to give consistent pressure to the brushstroke, resulting in a thin line of even tone.

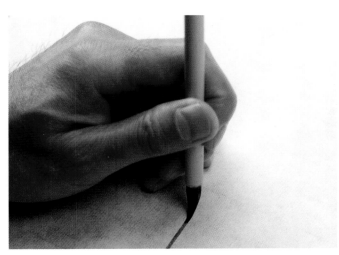

3. Even line

To draw a line of greater solidity, hold the a sakuyo-fude brush upright in the soko grip and bend over the tip of the brush (the inochige) slightly so that it remains constantly in the center of the line through the stroke. Practice the stroke until you can keep the pressure constant, allowing you to produce a strong, even, and powerful line, either straight or curved.

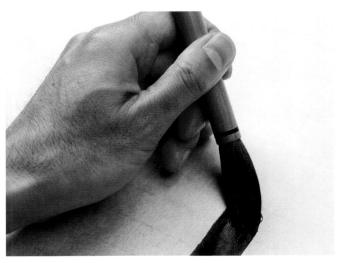

4. Broad line

Using a tsuketate-fude brush, draw a broad line, keeping the tone even. Although much wider than the basic, fine, and even lines shown here, you can still use a broad line to outline a subject. Hold the brush at an angle in the soko grip, keeping the arm still as you move through the stroke to give a solid, consistent tone.

Shaded Lines

Shaded lines use the same grips and hand positions as simple lines. The different tonal balance is created by using light ink on the main body of the brush and dark ink loaded only onto the brush tip. As with lines of a single tone, you can either create soft, blurred lines, or crisp, dry ones.

1. Light center, dark, soft sides

You can draw a line with light shade in the center of the line and dark shade at both sides. Hold the brush at an angle using the soko *grip (see page 30) and bend the brush tip (the* inochige) *a little so that it remains constantly in the center of the line. Dip the brush tip in water and apply dark ink to both sides of the bristles. Keep the movement fluid and straight, allowing the wet brush to send the ink to the outer edges of the line.*

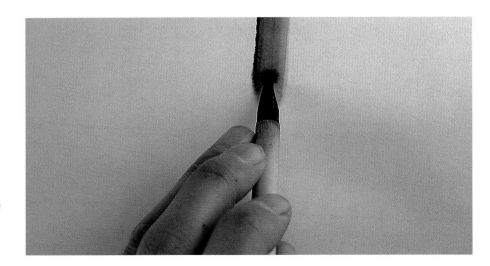

2. Dark tip, pale sides, soft edge

You can create this effect by using the tip and side of the brush with a technique called sanboku-ho *(see also page 32). First dip the brush in a light shade of ink, then apply dark ink only to the brush tip. Hold the brush at an angle to the direction of travel so that the body of the brush delivers a soft, light shade, while the tip gives a darker edge.*

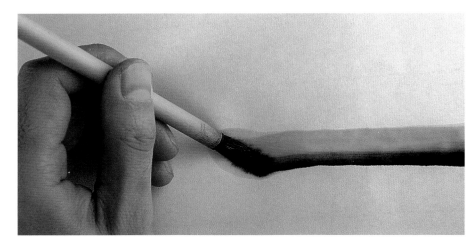

3. Multi-shade, hard edge

To draw a broad line with multiple shades and a sharp edge, use a dry tsuketate-fude *brush. Load it with ink in the same way, but use far less water, especially for the dark tone loaded to the tip. Hold the brush slightly more upright and, as here, use a brush with a good ability to hold ink.*

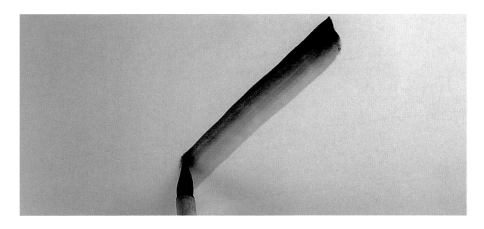

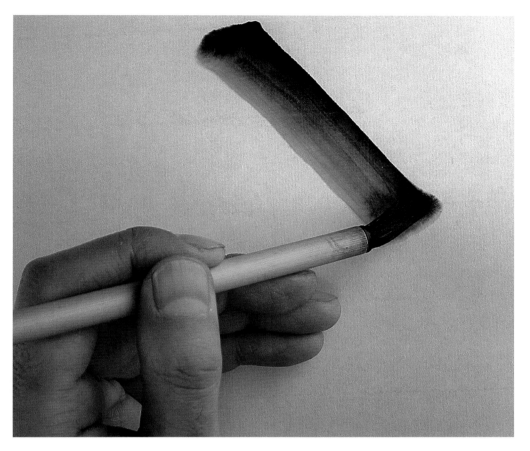

4. Soft blur

Taking a wet brush full of ink, use a method called junpitsu-ho to produce a soft, blurred impression. Holding the brush at an angle in the soko grip (see page 30), load it with different shades of ink, ensuring that both are very wet, allowing the darker edge to give a blurred outline as well.

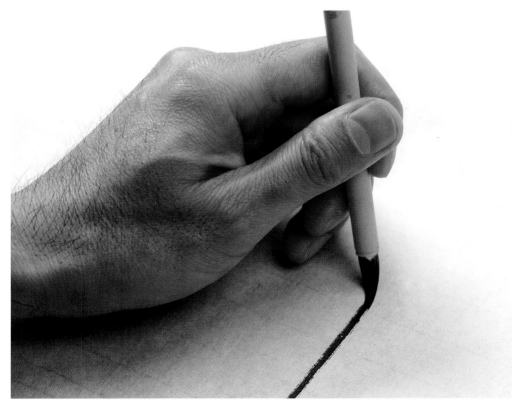

5. Dry ink

This method draws a line of even width with shades ranging from dark to light. Holding the brush upright, pull it straight with the tip gathered to one edge. You can let the tip create a dark line with crisp shade, and the side of the brush produce blurred, soft shade.

Creating Shape: Bamboo

Some brushstrokes can be used to create the shapes of objects, rather than just their outline. One of the most common subjects is the bamboo, whose stalks' ever-changing tones and shapes can be created in continuous brushstrokes which change their shape and pressure to indicate the joints and tones.

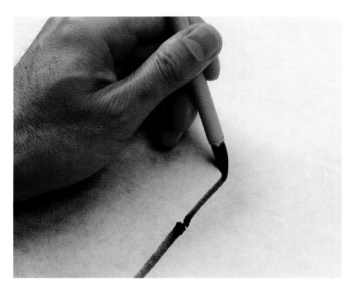

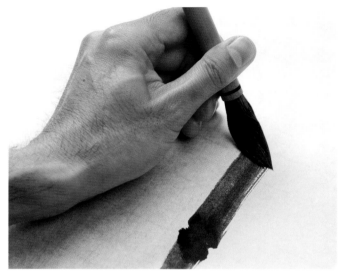

1. Creating a fine line of varying thicknesses

Ideal for showing the changing thickness of bamboo, this line is based on a rhythmic motion. Using the sakuyo-fude brush, here with dark ink, start by applying pressure at the brush tip for a moment before letting the brush lift to draw a line. Continue to pull the brush, alternating the pressure to make nodules of bamboo. The plant's form will be most easily created if you draw with an even rhythm.

2. Dry brush

Use the method known as mokkotsu-ho, working with a dry brush and no outline. Show the plant's characteristics by utilizing different shades of ink and changing the shape of the brush to create the shape of the plant. Use a brush that retains the ink well.

3. Creating a thick stem

To paint a bamboo with a thicker brush, work in a rhythmic motion to create the dividing joints of the stem. Take a tsuketate-fude brush full of wet ink, using the junpitsu-ho technique (see page 43). Here, light ink produces a soft impression. Apply light pressure to the brush at the start of each segment, imagining the line moving in the direction of the growth of the stem while trying to make a straight bamboo stalk.

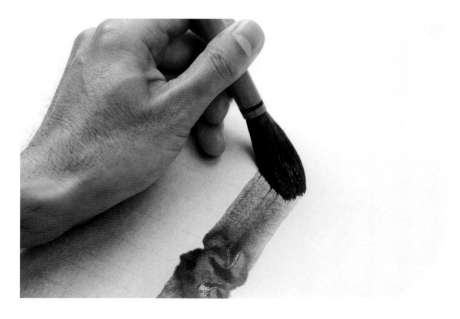

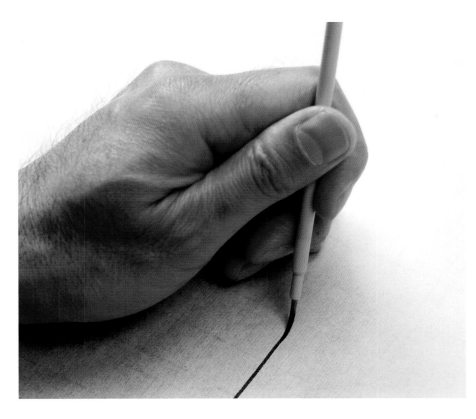

Creating a sharp line

You can draw a sharp and long line using a menso-fude brush. Keep your little finger on the table to maintain the pressure. This stroke is usually used in Buddhist painting, but it can also be helpful in detailed drawing, such as the eyes and mouths of animals or the petals of flowers.

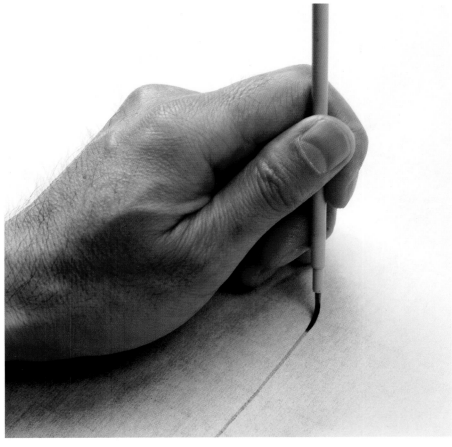

Creating a sharp, pale line

Light ink can become easily blurred on the paper, but with the menso-fude brush you can draw a sharp line. As the menso-fude transfers your inner emotion easily, focus yourself before you start painting. Keep the bristles in the center of the line but ensure that the brush is very wet to give an even shade.

Creating Flowers: Blossom

The plum tree is one of the flowering trees used as a classic motif in Japanese painting since it was brought into Japan from China in the seventh century. Celebrated in song, its edible fruit was preserved for food and used as a medicine. As the February blossoms announce the advent of spring, it is not unusual to come across swathes of pale pink blooms surrounded by crisp snow. Because of the flowers' perseverance, the plum is the symbol of the happy warrior, and this virtue of strength through grace explains why the plum blossom is frequently taken up as a subject for *sumi-e*.

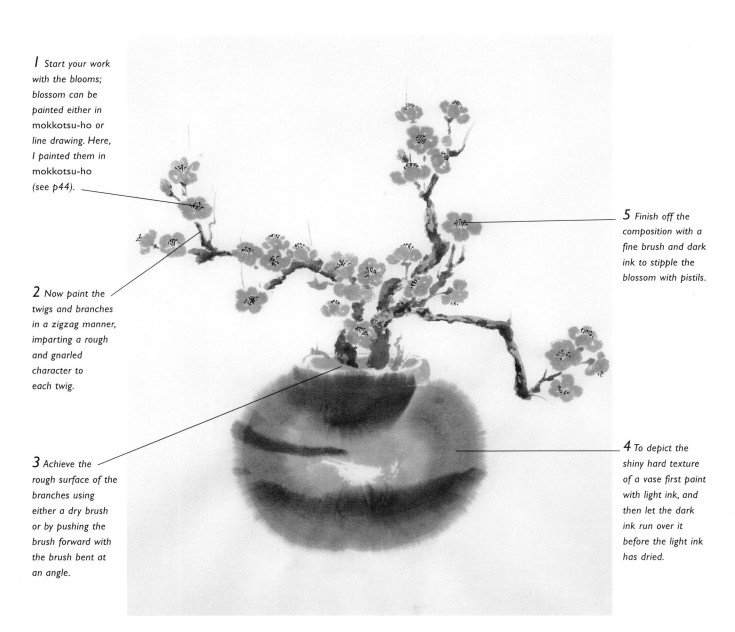

1 Start your work with the blooms; blossom can be painted either in mokkotsu-ho or line drawing. Here, I painted them in mokkotsu-ho (see p44).

2 Now paint the twigs and branches in a zigzag manner, imparting a rough and gnarled character to each twig.

3 Achieve the rough surface of the branches using either a dry brush or by pushing the brush forward with the brush bent at an angle.

5 Finish off the composition with a fine brush and dark ink to stipple the blossom with pistils.

4 To depict the shiny hard texture of a vase first paint with light ink, and then let the dark ink run over it before the light ink has dried.

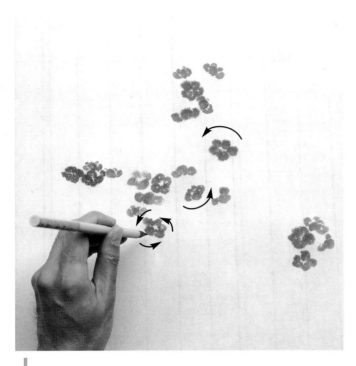

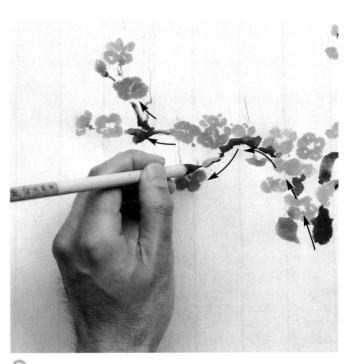

1 Start with an arrangement of blossom, keeping the blooms scattered naturally. Load three different shades of ink on the medium brush, or *tsuketate-fude*. Paint each flower with *mokkotsu-ho* (see page 44) circular strokes, as shown above.

2 Now link the blooms with the twigs and branches, moving out from the center of the blooms. Use the upright brush, *chokuhitsu-ho* (see pages 31 and 32), depicting the rough texture by applying dark and light tones of ink.

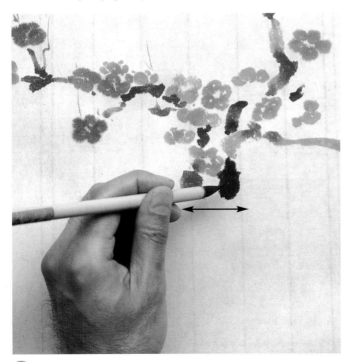

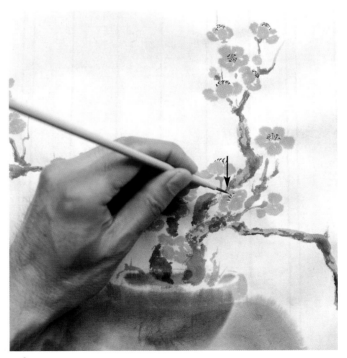

3 Use the "dry brush" method (see page 44), applying a small amount of ink to the brush to produce the scratched effect for the trunk. Leave a small white space between trunk and vase.

4 To complete the piece, use the fine brush, or *menso-fude* (see page 21), to draw in each pistil. Load the brush with dark ink, but apply the minimum amount for a fine, sharp line.

Creating Flowers: The Iris

Although the iris has been portrayed in *sumi-e* pictures by Japanese artists for centuries, its elegance and beauty is remarkably easy to capture. Use a medium-weight brush (*tsuketate-fude*) and concentrate on creating the evenly graduated shapes of the petals, leaves, and stem by the way you drop and lift the brush onto and away from the paper with smoothly changing pressure.

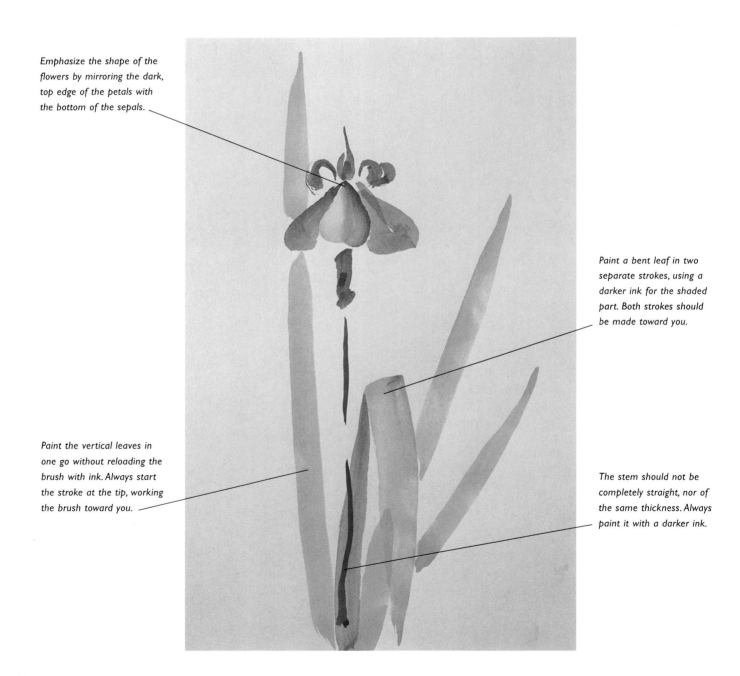

Emphasize the shape of the flowers by mirroring the dark, top edge of the petals with the bottom of the sepals.

Paint a bent leaf in two separate strokes, using a darker ink for the shaded part. Both strokes should be made toward you.

Paint the vertical leaves in one go without reloading the brush with ink. Always start the stroke at the tip, working the brush toward you.

The stem should not be completely straight, nor of the same thickness. Always paint it with a darker ink.

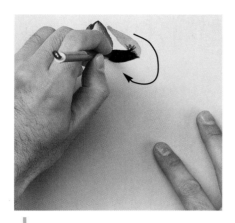

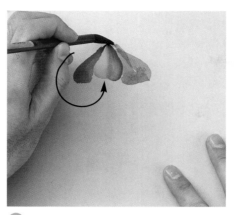

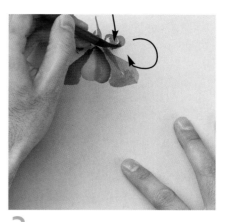

1 Using a *tsuketate-fude* loaded with ink in the *sanboku-ho* technique (see page 32), paint the iris's three petals. Use a circular stroke that starts at the top of the petal with the tip of the brush. As you reach the bottom of the petal, turn the brush and flatten it against the paper, widening the stroke and darkening the ink.

2 Finish the petal by returning to the start of each stroke and lifting the brush gently up and away to give each petal a sharp tip.

3 With the same brush, paint the sepals in quick, rounded strokes, then the vertical tip of the stalk.

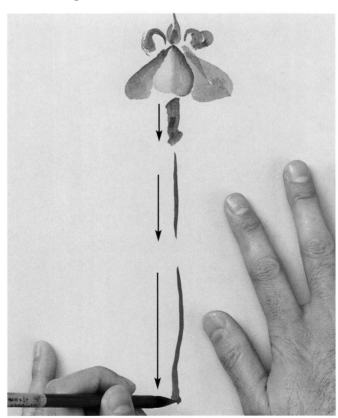

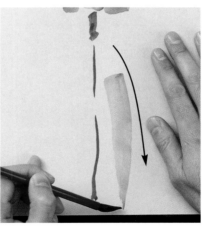

5 Add the first drooping leaf by flattening the brush against the paper and pulling it toward you, lifting gradually to make a sharp tip.

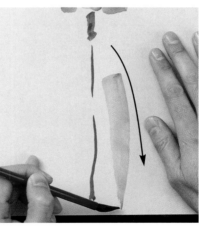

6 Include the vertical leaves by starting with the tip of the brush and gradually flattening the hairs against the paper. Add the base of the drooping leaf in darker ink.

4 Paint the stalk in a single movement, lifting the brush twice. The gaps both add movement and allow space for leaves to cross the stalk.

Flower Subjects and Composition

Traditionally, oriental painting has been inspired by nature. Its primary motifs include the "Four Gentlemen": the chrysanthemum, bamboo, wild orchid, and plum blossom. A good way to learn *sumi-e* is by painting plants and simple flowers—practice single brush strokes in the straight lines of a stem, and combinations of curved and straight lines in leaves and flowers.

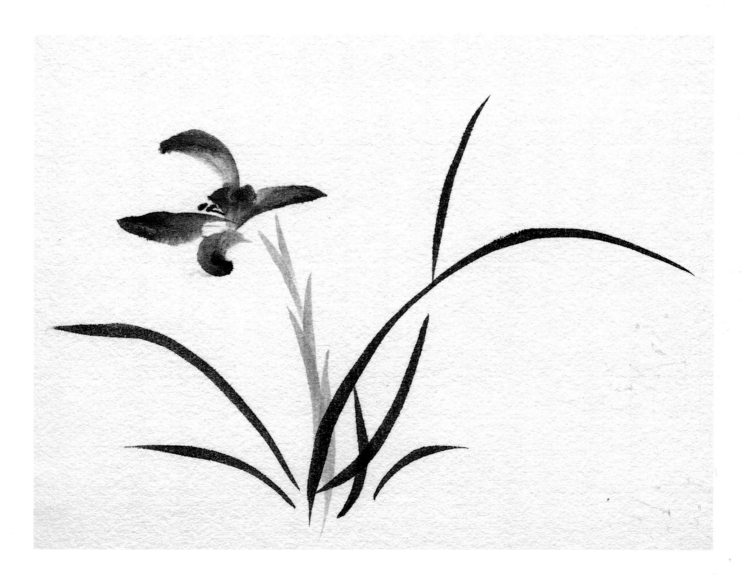

Wild Orchid

The wild orchid is one of the Four Gentlemen. Paint the leaves with an upright tsuketate-fude brush, twisting your fingers half-way through to make the leaves turn over. Make the tip of the brush paint the roundness of the flower by touching the tsuketate-fude, loaded with medium ink, to the paper and twisting the brush before gently drawing it away from the paper.

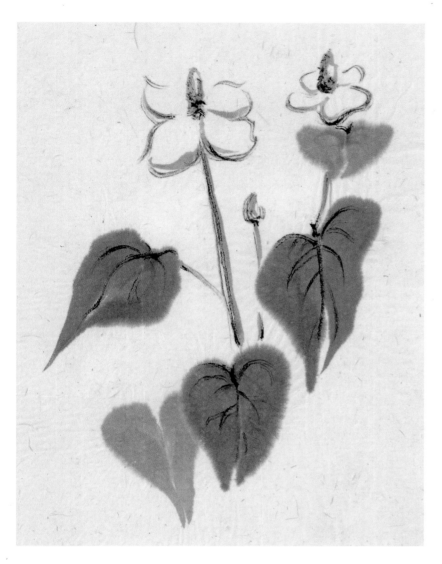

Chameleon Plant

This plant has been familiar to the Japanese as a medicinal herb since ancient times. Its four white petal-like bracts and small yellow spike are painted with a dry, upright brush. Leaves are painted with the mokkotsu-ho technique (see page 44) with medium ink for the nearer ones, and light ink for those in the distance. Draw in the leaf veins with an upright brush using dark ink.

Plum Blossom

The plum blossom is also one of the Four Gentlemen. The straight lines of the plum tree's branches and the curved lines of its flowers are considered to be especially good examples for practicing brush strokes (see pages 32–39).

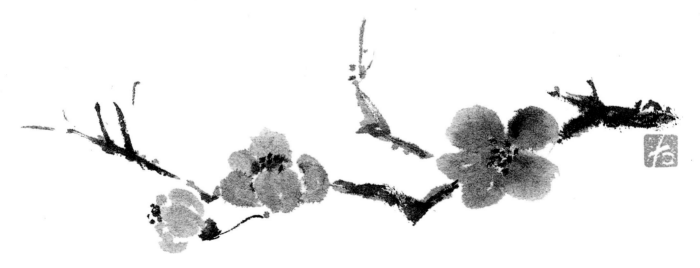

Creating Birds

A Japanese bush warbler is painted sitting among the blossom on the branch of a plum tree. Said to announce the coming of spring, both the warbler and the plum tree have become symbols of the season, epitomized especially in the ancient tradition of *haiku* poetry (see *Inspirations*, pages 120–123). Painting the bird requires remarkably few strokes; take care with the proportions and, after only a little practice, you will be able to master many types of Japanese song bird, each with its own symbolic value.

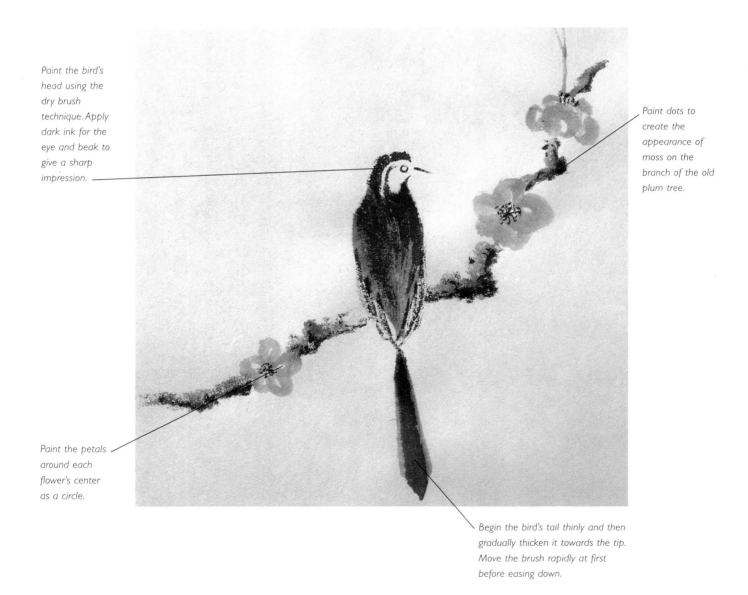

Paint the bird's head using the dry brush technique. Apply dark ink for the eye and beak to give a sharp impression.

Paint dots to create the appearance of moss on the branch of the old plum tree.

Paint the petals around each flower's center as a circle.

Begin the bird's tail thinly and then gradually thicken it towards the tip. Move the brush rapidly at first before easing down.

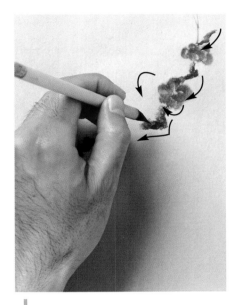

1 When painting the branch of the plum tree, move the brush in short, slanted strokes and leave an appropriate space for the bird.

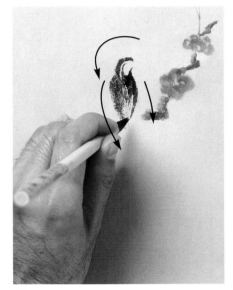

2 Use dark ink with a dry brush to draw the contour of the warbler's body. Paint the bird's back with light ink using the *sokuhitsu-ho*, slanted brush technique (see page 30).

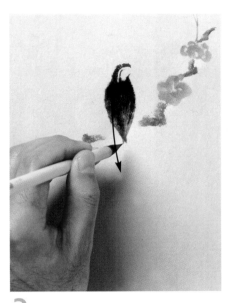

3 When painting the bird's body, take care you do not apply too much light ink to the *sakuyo-fude* brush or it will disperse too much, creating a fat body.

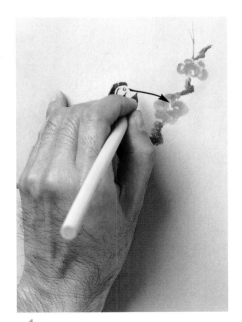

4 To create a sharp eye and the beak, remove the excess ink at the root of the *sakuyo-fude* with a rag—dry brushing will create a sharp impression.

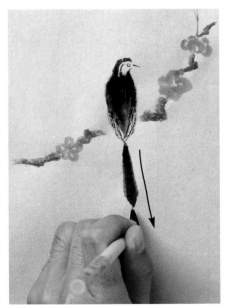

5 Paint the center tail feather with dark ink and the outer pair of tail feathers with light ink.

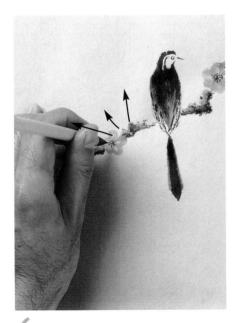

6 To create the rough texture of the branches, first paint the bark with light ink but drop in the dark ink before the light ink dries.

Bird Subjects and Composition

Birds have long been loved by the Japanese, and *sumi-e* is ideal for capturing their loveliness and vivid movement. Practice a few key areas: when painting the bird's head, do not apply much ink and draw distinctly; create the grand impression of a big bird, or the nimbleness of a small bird with the speed of the brush strokes; and position the eye and direct the beak to produce a lifelike posture.

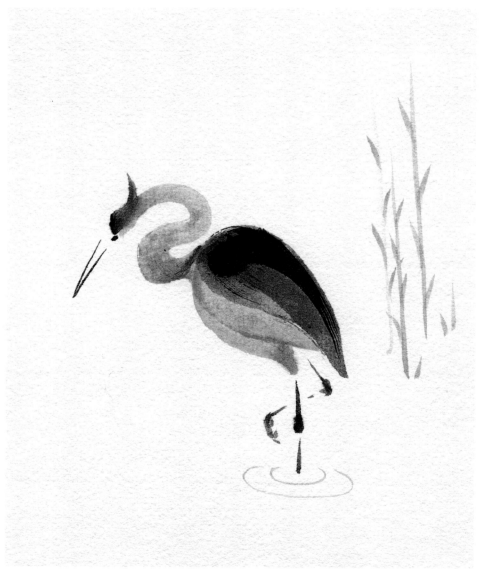

Heron

Paint the whole body of this heron as one: draw the beak and eye with an upright menso-fude brush, then use a slanted tsuketate-fude brush to paint the head and the body. Work the neck and stomach in light ink, and the feathers with dark ink to produce the three-dimensional effect. It is important to draw the leg firmly.

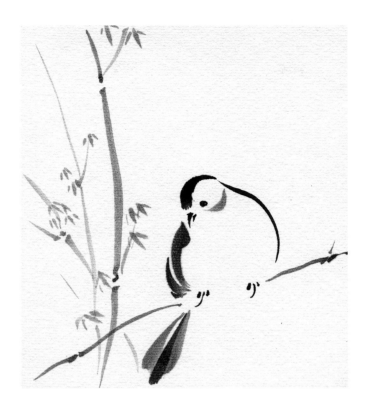

Dove

The dove is universally regarded as the symbol of peace, and it is no different in Japan. The painting here depicts the pigeon from the front, emphasizing its softness. Drawn in outline using a sakuyo-fude brush, paint the head first in dark ink, the body and center tail feather in medium ink, and then the outer pair of tail feathers in light ink. Draw the bamboo in light ink, so it does not dominate the subject.

Gray Wagtail

Paint the body to give the bird a soft plumpness. Then paint the head and finally the tail feathers. I have emphasized the fluffiness here, encouraging you to imagine the cool season of Fall, which is symbolized by the wagtail in Japan.

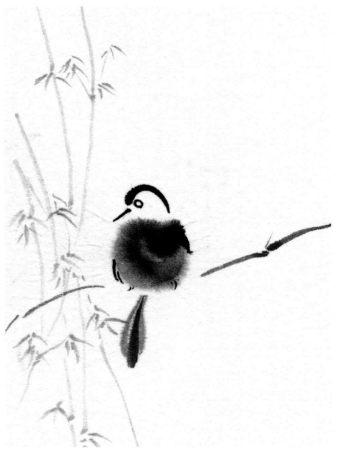

Creating Animals

One of the great strengths of *sumi-e* is that it can render a traditional design in a small space using the simplest techniques and very few shades and colors. Over many centuries, a major purpose of the art was communication to the people of Japan, so it had to be very easy to understand. Because of this, *sumi-e* paintings, especially figures and animals, were often painted with greatly exaggerated outlines. This cat is finished off with a touch of shading in western style.

On the "land" of the ink stone, twist the bristles of sakuyo-fude. With the split bristles, paint the cat's whiskers by lightly patting, drawing them in clumps rather than one by one.

When you are drawing sharp lines, twist the brush on the ink stone and use the very edge of the brush tip.

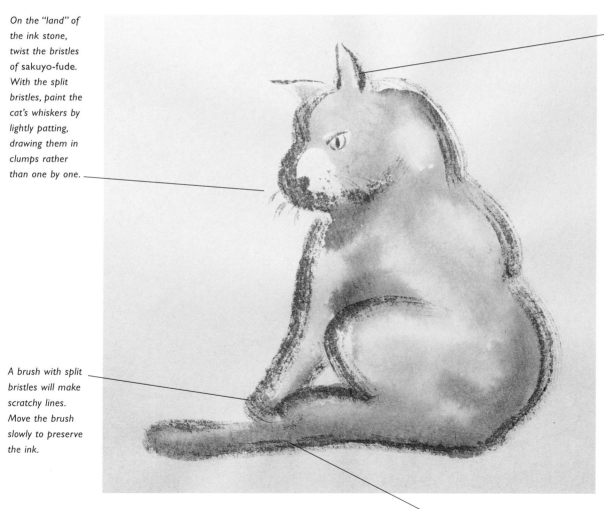

A brush with split bristles will make scratchy lines. Move the brush slowly to preserve the ink.

Draw the cat's tail in a single breath or you will make a shaky line. With a split sakuyo-fude, paint in one stroke from the hip to the tip of the tail.

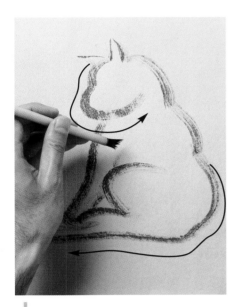

1 With the split bristles of the *sakuyo-fude*, draw the figure of the animal as a series of circles. Do not hesitate and let the dry brush create beautiful lines.

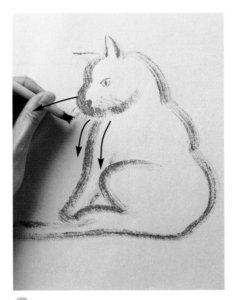

2 For the nose, eyes, mouth and whiskers, again use the split bristles of the *sakuyo-fude*. Test which part of the brush tip paints the sharpest line.

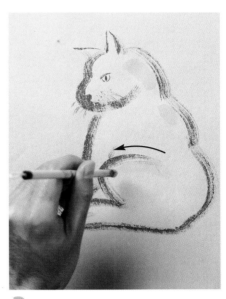

3 Apply the lightest shading down the cat's back and along its haunches with small, circular brush motions, somewhere between a line and a dot.

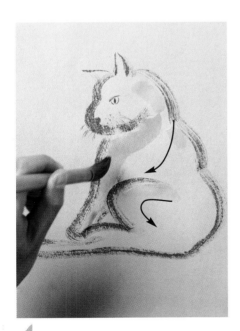

4 Before the ink dries, use the *tsuketate-fude* brush to fill the body of cat, leaving only the nose and mouth. Work quickly to achieve good gradation of color.

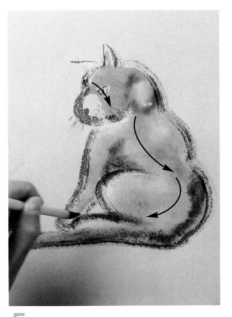

5 As the paper absorbs ink rapidly, the color will be very light. Produce the contrast you need by applying a darker color than may seem necessary.

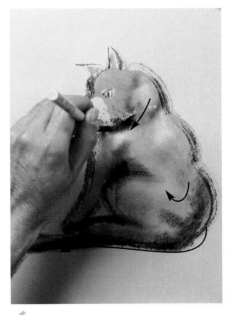

6 The fourth shading is the darkest part. As the *sumi* color becomes very light, apply very dark ink forcefully, as if you were pushing the ink into the paper.

Animal Subjects and Composition

Sumi-e, which takes up themes from the natural world, includes animals, fish and insects as important motifs. As with many Japanese plants, these animals are a part of the seasonal vocabulary that describes the changing year. Practice painting the animals that live around your home in order to master the techniques that capture their vivid movement.

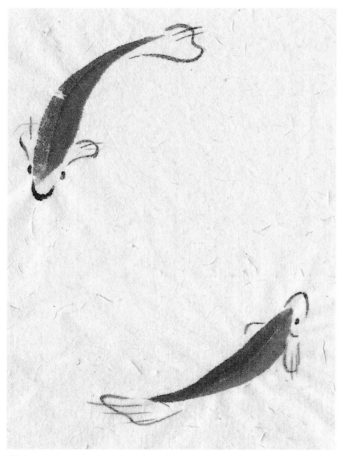

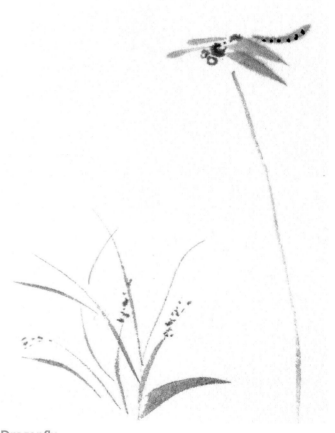

Fish

The figures of the fish swimming freely in the water can be painted by giving supple touches to the body and fin. Paint the fish's body using the mokkotsu-ho technique (see page 44) and draw in the details with dark ink, imagining the correct location of each part as it moves and the direction it is pointing at. Paint vividly so as to suggest swift movement.

Dragonfly

The dragonfly is typical of the Fall and the motif is often used to decorate poems and kimono. To describe its swift darting movement, paint it lightly, first depicting the eyes with line drawing, and the back with dark ink. Add the thorax, wings, and abdomen in light ink using the mokkotsu technique with a slanted brush. Add the accents to the abdomen in dark ink to finish.

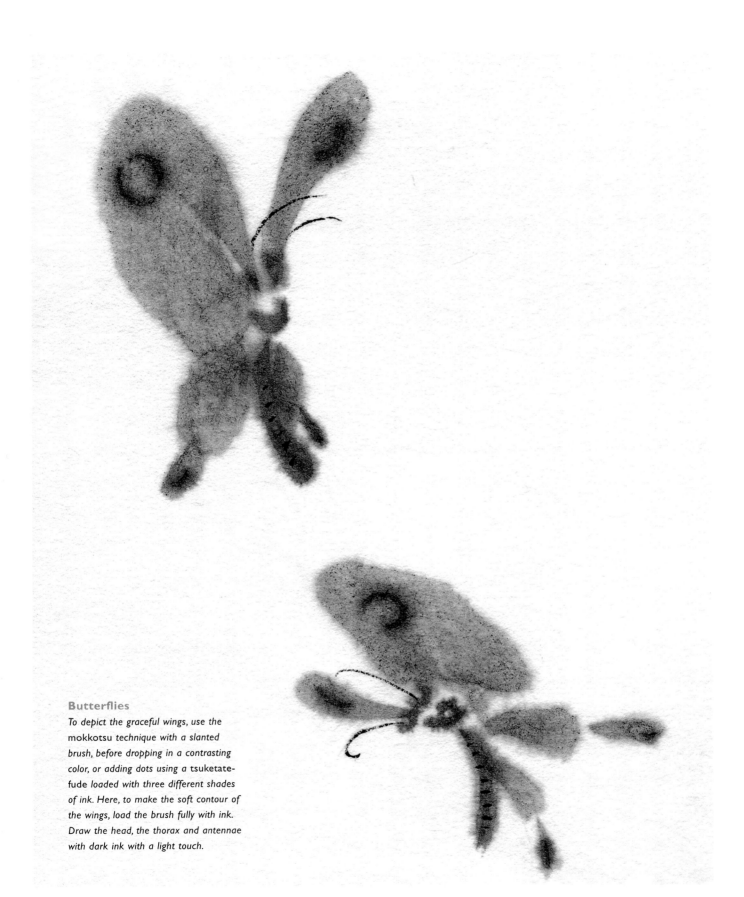

Butterflies

To depict the graceful wings, use the mokkotsu technique with a slanted brush, before dropping in a contrasting color, or adding dots using a tsuketate-fude loaded with three different shades of ink. Here, to make the soft contour of the wings, load the brush fully with ink. Draw the head, the thorax and antennae with dark ink with a light touch.

Creating Landscapes

When you paint western landscapes in *sumi-e*, you can create a distinguished world. You may have seen the traditional oriental landscape paintings named *sansuiga*, but do not, however, feel restrained by their traditional subjects of water and mountain. Instead, use the style to paint any kind of landscape—here a pastoral view. When painting landscapes, it is most important to capture the essence of the scene in your depiction. Create the focal point first before giving the painting balance, while also focusing on the change of *sumi* ink color and the brush strokes.

Choose a focal point—here it is the steep hills on the far horizon.

Use various tones of sumi *ink to give both strong and weak intonation in the strokes when painting landscapes.*

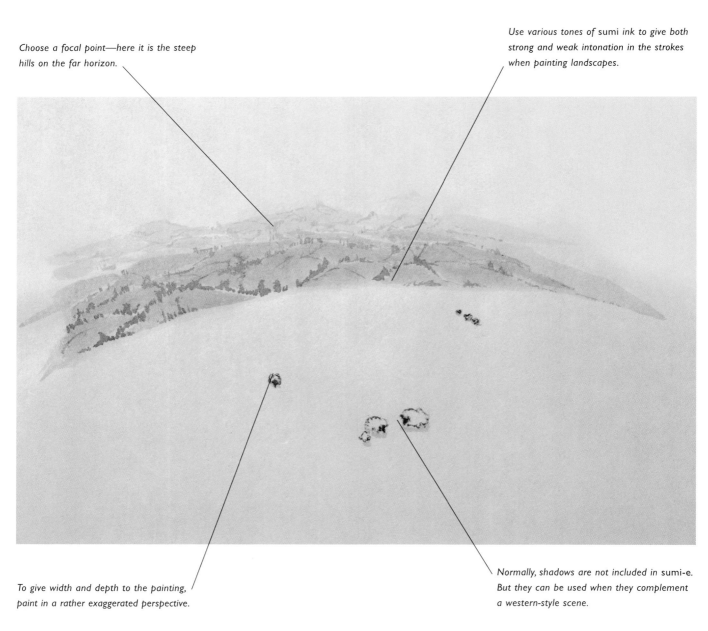

To give width and depth to the painting, paint in a rather exaggerated perspective.

Normally, shadows are not included in sumi-e. *But they can be used when they complement a western-style scene.*

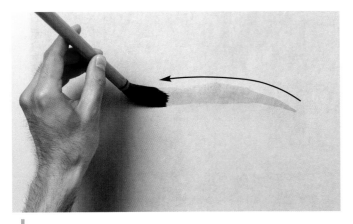

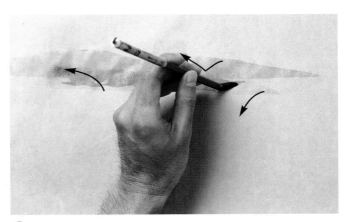

1 Paint the steep range of hills in the background using the *tsuketate-fude* brush, fully loaded with medium ink. Do not hesitate, but paint in a single movement using a slanted stroke.

2 Paint the countryside with a medium-size brush loaded with medium ink, as if you were drawing a series of diamond shapes. Paint while the previous stroke is still half wet.

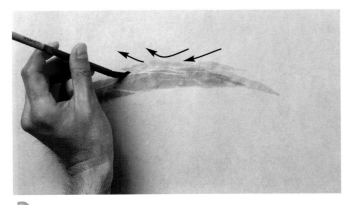

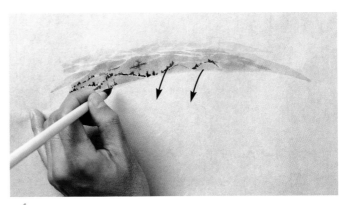

3 Use the same medium brush to paint the hills behind. Use light ink to show the perspective. Depict their steep elevation by gently stroking the brush along the diamond shapes.

4 Use an upright brush to draw the trees and stone walls. Paint the scenery near to you with dark ink, and that which is further away with light ink.

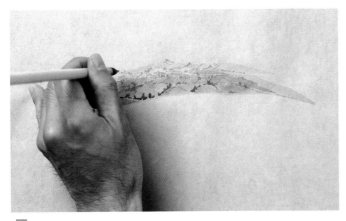

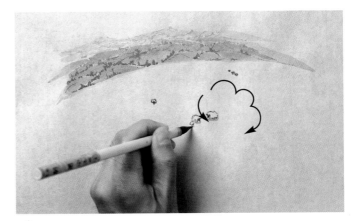

5 You must remind yourself not to paint the landscape exactly as you see it, but rather try to create a beautiful scene as a whole. Vary the rhythm and tone as you work.

6 Draw the sheep in the foreground with an upright brush. Use the *chokuhitsu-ho* technique (see page 31) to depict only the outline of the subject.

Landscape Composition

Background is never painted in *sumi-e*. Instead, appreciate the beauty of the air, water, and earth that are implied by the white space. The amount of information included in western landscape painting seems to be a great deal. By contrast in *sumi-e*, what is important is how much you can simplify the information and deform the original figure in order to emphasize the impression.

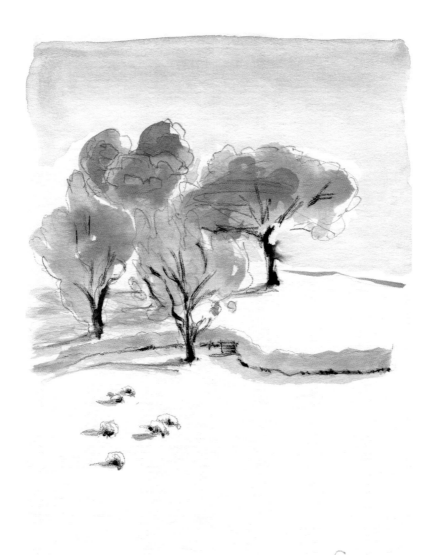

Fore, middle, and back

In this sketch of a pastoral landscape, I have used pencil and watercolor paints in addition to sumi ink. (See also Open-air Sketching, *page 100.) Only the most basic features have been included. Minimal colors are used to emphasize the pureness of the scene with the white space left untouched.*

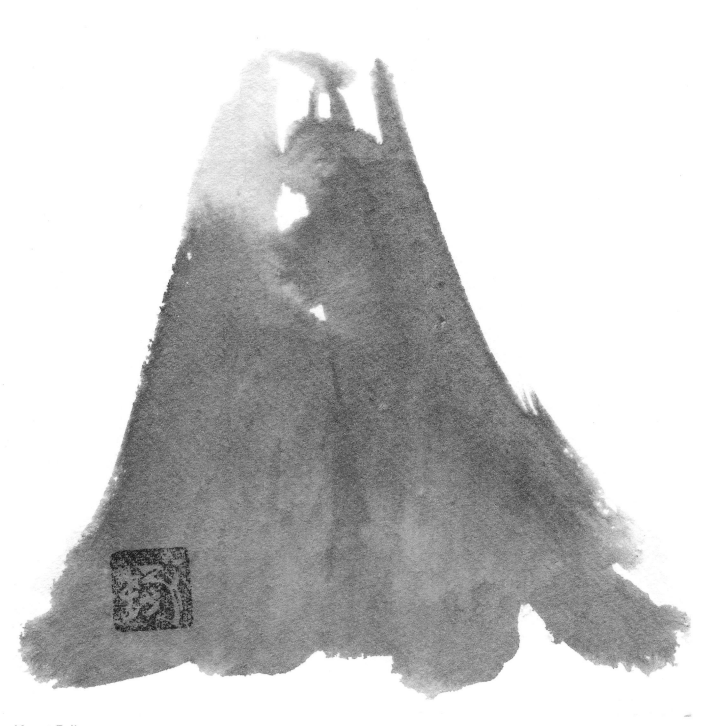

Mount Fuji

Although the mountain actually has a more moderate slope when compared to the daring rendering of this painting, deformation is acceptable if the artist succeeds in creating a strong impression. Mt Fuji's legendary ability to reach heaven has been depicted by the dark ink and dynamic strokes, imparting a strong impact.

Composition Images

Sumi-e is not an art that attempts to depict the world as realistically as possible. Rather, it is an impressionist art, leaving the feelings of the artist strongly on his works. Composition is crucial: the elements of the subject are filtered through the eyes of the artist, who then reconstructs them into a beautiful work that also includes areas of emptiness to display the elements which remain.

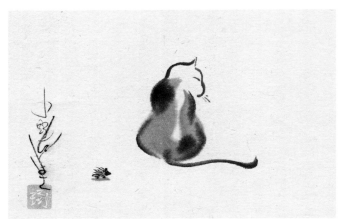

Animals: Cat and Hedgehog

Here, the hedgehog is painted smaller than it really is, making the cat the center of the painting. By placing the supporting element here, the lovable character of the cat, the main subject, is emphasized and movement is added to the painting.

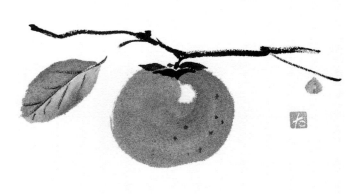

Plants: Persimmon on Branch

The seal is also an important element of a beautiful composition. Here, its placement and small size emphasizes the subject, a fine persimmon. Take particular note of the location of the seal; for you can balance the entire painting by proper placement or sizing of a seal.

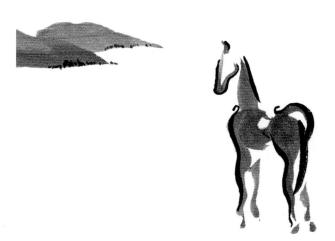

Animals: Horse and Mountain

The perspective in this landscape is created by drawing the far away object—the mountain—smaller, and the nearby object—the horse—larger. By creating this wide open space a grand impression can be depicted in a very limited area of paper.

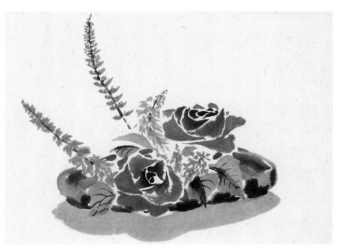

Plants: Rose Bowl

These roses are displayed in a Japanese style arrangement. The Japanese consider the simplest and boldest layouts to be the best. Sumi-e and Japanese flower arrangement share common ground as spiritual and esthetic expressions.

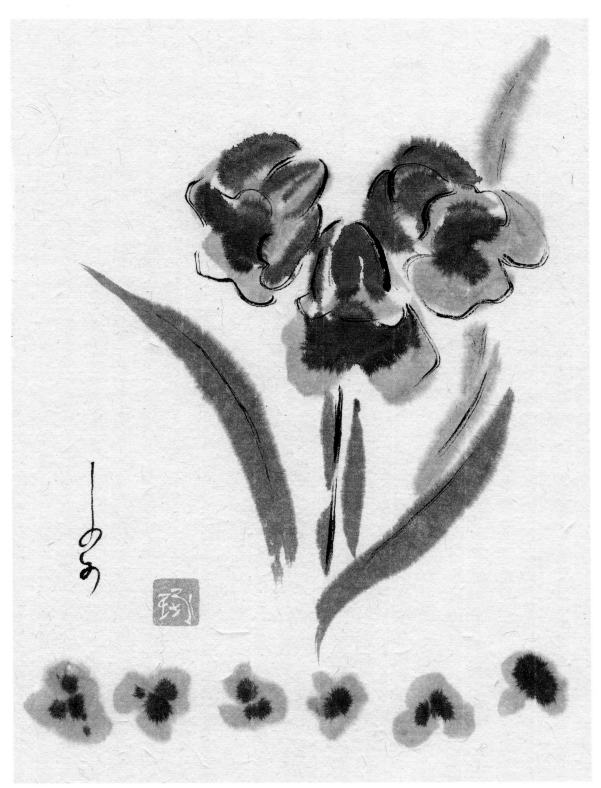

Plants: Tulip

On the same sheet of paper that I painted a tulip plant, I added a frieze of tulip petals below. Although this is not a traditional style of sumi-e, it adds a modern and rhythmic impression to the entire work. In this way, you can create an artwork uniquely your own by taking up the challenge of a new composition.

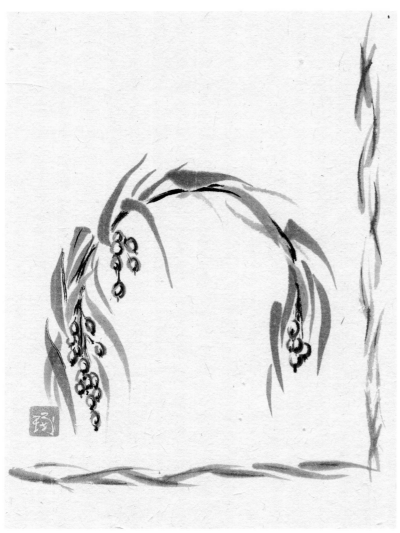

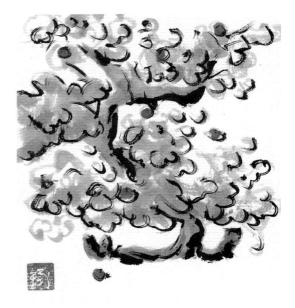

Plants: Old Apple Tree

The old apple tree is painted with an S-shaped composition, a style frequently used to paint trees. Although the subject covers the painting area fully, because it is painted in the shape of an "S," it does not create an oppressive feeling—but becomes a stable picture. The apple is colored purple—you can paint using your own imagination.

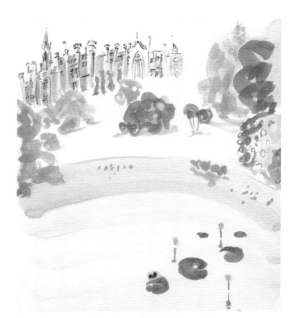

Plants: Job's Tears

This painting of Job's Tears loaded with seeds, hanging its head down, also has a design of leaves placed around two sides. It is advisable to plan the composition by imagining the herb waving in the wind with leaves flowing. Be sure you hold the image of the final painting in your mind before you begin to paint.

Landscapes: Castle with Yellow Flowers

In sumi-e, treasure the impression you receive from the subject. Especially when painting landscapes with buildings, the composition is decided by what you want to emphasize. The painting here is a well-balanced example of two subjects, one in the background, the second nearer to you, adding a light touch of color with the lilies.

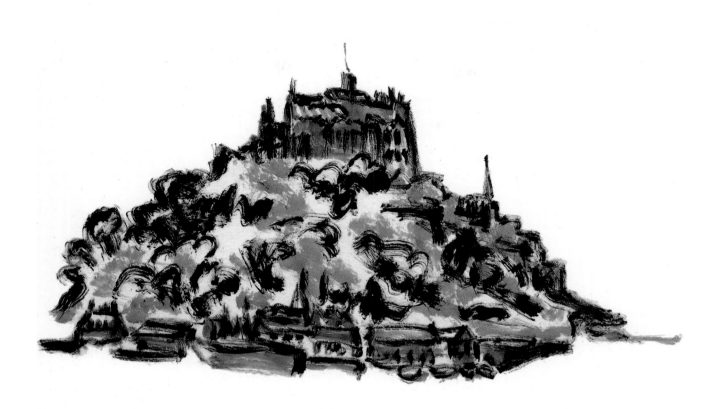

Landscapes: Castle by the Ocean

Imagine the ocean flowing through the white space of the painting. All but the central subject is eliminated, letting the artist show only what he wants. When painting European or American landscapes in sumi-e, you can enjoy creating an interesting composition that is not usually seen in Western paintings.

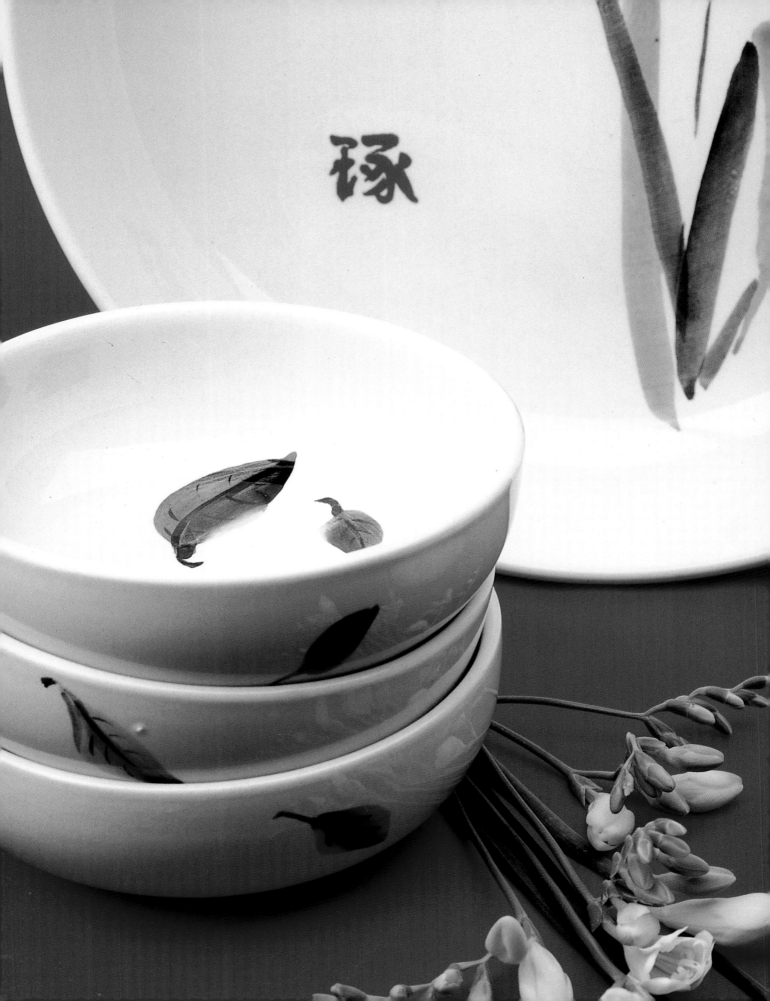

The Projects

Sumi-e has been closely related to Japanese culture for many centuries and even after so long a period of time, it remains one of the favorite and most beloved art forms of the people. Here I have used *sumi-e* in a variety of projects that will add sparkle to your home and everyday life. Examples include framed *shiki-shi*, greetings cards, and beautiful scented sachets. Also, add *sumi-e* covered lampshades and cushions to your home to bring an oriental flavor to your interior decoration.

Most importantly, don't feel any anxiety when learning to paint *sumi-e*; simply try some of the projects introduced here and create alternatives of your own.

Greetings Cards

It can be a challenge to make a card for a special occasion that is both beautiful and truly personal. Hand-painted postcards, known as *etegami,* are popular in Japan nowadays, and you can make your own by painting *sumi-e* on a simple card and presenting it as a unique gift. The way the plain paper is folded echoes the form of a *kimono*—showing only the collar of the plain under-*kimono* in contrast to the brightly patterned outer layer. To personalize your work, turn to the *Inspirations* section on pages 118–126 for a series of Western names and *haiku.*

You will need

White paper 8 × 11 in.
 (20 × 28 cm, A4)
Colored paper 8 × 11 in.
 (20 × 28 cm, A4)
Ruler
Paper cutter
Menso-fude brush
Sumi ink or watercolor
Seal
Seal ink

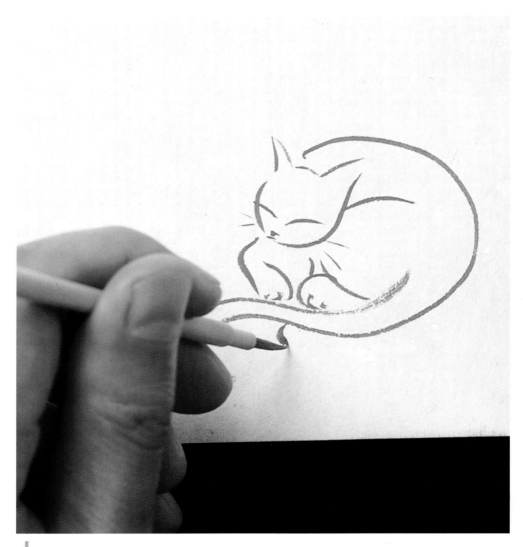

| To prepare the area of paper to be painted, fold the paper lightly in three and mark off the end to be worked. Prepare a thick watercolor paint using the *menso-fude* brush. To make the round shape of a cat's back, paint in a single stroke without stopping half-way.

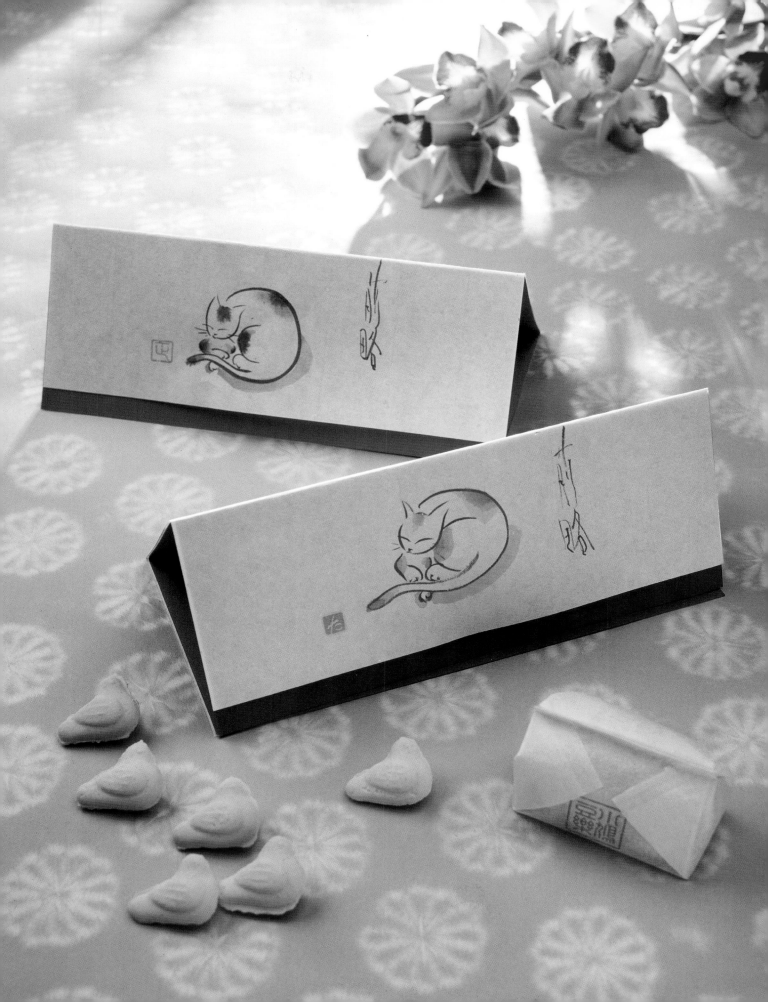

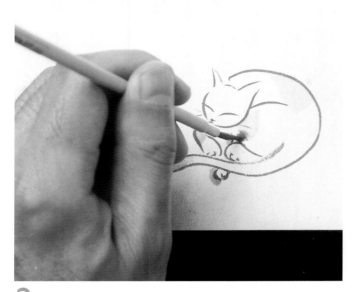

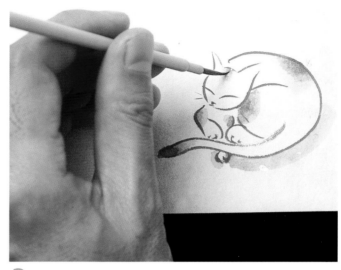

2 By drawing a circle for the contour of the cat, the cat looks as if it is curling itself up. Do not apply too much pressure on the brush or the line will be too thick.

3 In contrast to *washi* paper, ordinary paper takes far longer to absorb the ink. Apply the light color first and then drop the patches of dark color into the wet ink before the light color has completely dried.

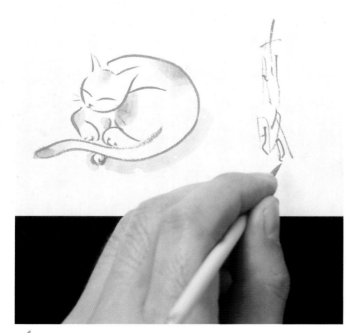

4 Write the greeting message on the card. The ratio of white space to the message should be eight to two, whether the words are written across or lengthwise. But remember that the message is not the central focus of the card.

5 A seal is usually related to an image by being placed on a line extending out of the object, or in a natural position around the painting. In this case, it is placed in the bottom left, on the extension line of the cat's tail.

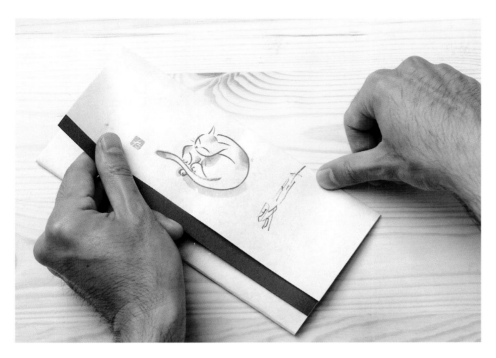

6 Lay the colored paper under the white paper on which you have drawn the cat and fold them in three. Cut off a strip of white paper ½ in. (1 cm) from the bottom of the sheet so that the colored paper protrudes.

7 If you wish, write your own message on the inside of the card.

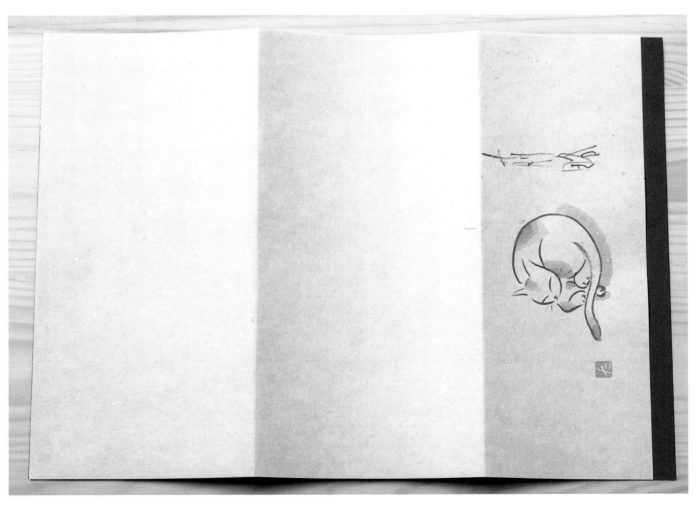

Canvas Cushion of the Ocean

As a tribute to the legendary eighteenth-century Japanese artist and printer Hokusai, this sturdy canvas cushion features a rolling wave, frothing with vigor and spirit. Created in dark blue *sumi* ink to match its maritime subject, the canvas is primed with milk to absorb more color and to allow the ink to diffuse through the fabric. You can use the simple technique shown here to create a set of cushions on themes of the ocean, or to adorn fabrics with the motifs of your choice.

1 Prepare a bowl with 30 fl. oz. (850 ml) of water and 5 fl. oz. (150 ml) milk. Soak the cushion cover and wring it out, before stretching it to dry for about a day.

2 Insert a sheet of cardboard into the cushion cover before painting to prevent the ink from soaking through to the rear side. It will also help you to paint easily.

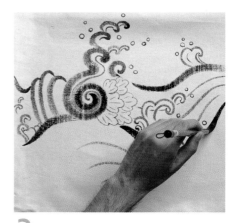

3 Grind the *sumi* well to make dark ink and mix it with milk. If you are using fabric paint and thickener, use it according to the pack instructions.

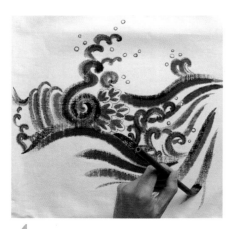

4 Mix a lighter ink and use the *sakuyo-fude* to draw the contrasting color. If the fabric does not disperse the ink much, apply the brush strokes more slowly.

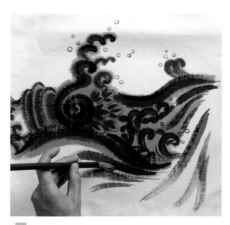

5 Work slowly—remember that although it takes time for the light ink to be absorbed into the cotton it will blur more than you expect. Prepare acrylic ink and a stencil brush for the seal.

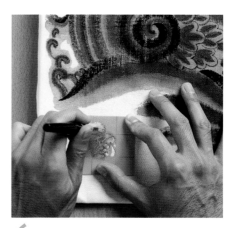

6 Make the seal. To fix the ink, fold and wrap the cushion carefully in plain paper tied with string. Steam it in a bamboo steamer for an hour. Remove, unfold, and allow to dry.

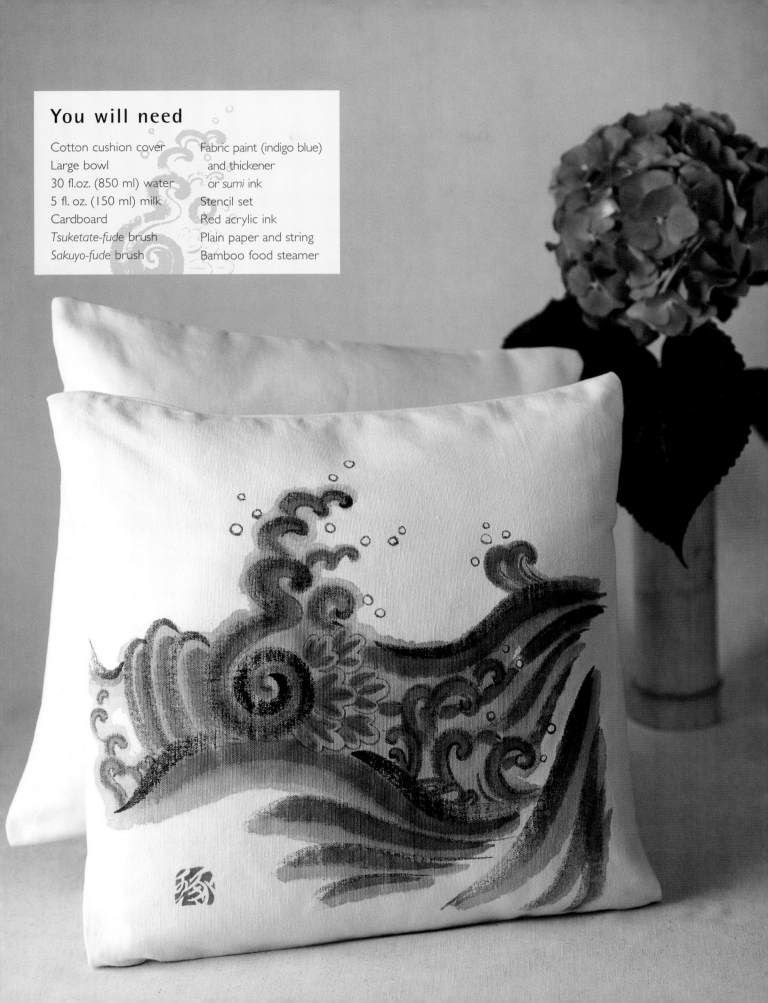

You will need

Cotton cushion cover
Large bowl
30 fl.oz. (850 ml) water
5 fl. oz. (150 ml) milk
Cardboard
Tsuketate-fude brush
Sakuyo-fude brush
Fabric paint (indigo blue)
 and thickener
or *sumi* ink
Stencil set
Red acrylic ink
Plain paper and string
Bamboo food steamer

Flower and Bamboo Tiles

Nothing complements the elegance of the black lines of *sumi-e* so much as a plain white background; and the graphic quality of the strokes is highlighted here by a plain white ceramic tile. The color is fixed by baking the unglazed tile in a kiln, where the absorbed colors take on a rich shine; imagine this effect as you paint. Create a set of heatproof trivets for the kitchen using the examples on pages 94–95, or, as the tiles are waterproof, paint a series of goldfish and waves to decorate your bathroom.

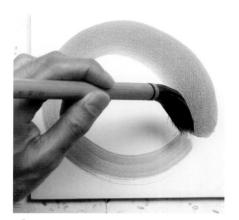

1 Fill the large *tsuketate-fude* brush fully with black ceramic ink mixed with water. Paint a circle around the edge of the tile in a single stroke.

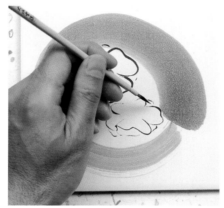

2 Let the circle dry and load the small *menso-fude* brush with a dark mix of ink and water to draw the sharp contours of the flower petals.

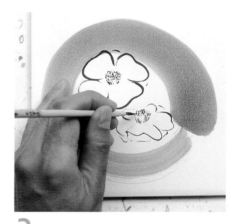

3 Emphasize the importance of this flower by painting the petals and centers of the remaining flowers in a slightly lighter ink shade.

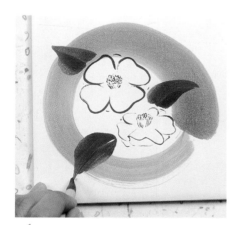

4 Fully load the *sakuyo-fude* with ink to paint the leaves. Using the *mokkotsu-ho* technique (see page 44), paint in the veins of the leaves but not their outline.

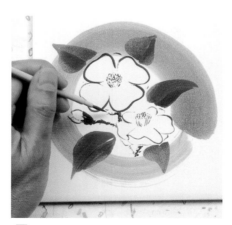

5 Use the *menso-fude* loaded with black ink to draw the branches in a slightly gnarled manner.

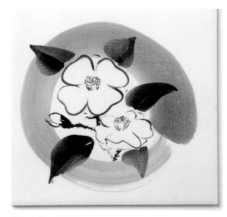

Finished Tile
When complete, the tile should be fired in a kiln to fix the ink.

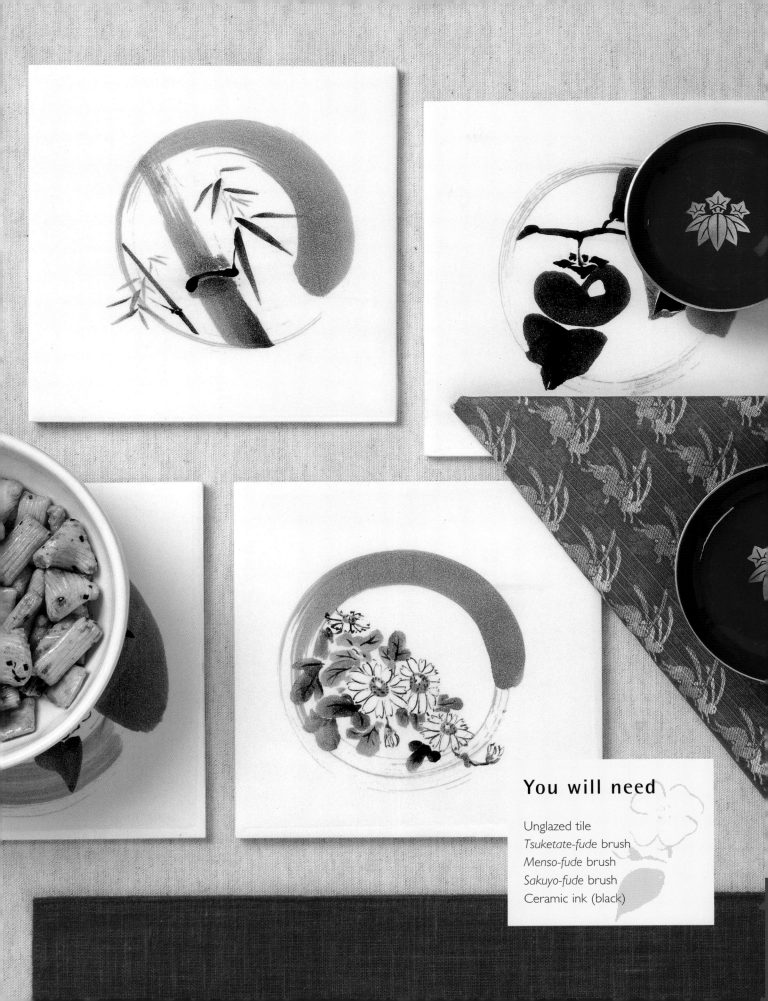

You will need

Unglazed tile
Tsuketate-fude brush
Menso-fude brush
Sakuyo-fude brush
Ceramic ink (black)

Falling-leaf Ceramics

With its illustrious history of ceramic painting and developments in pottery, Japanese art is ideally suited to the decoration of dishes for the home. With their motifs of leaves falling through the air on a pure white dish, and a strikingly simple iris on the main platter, they epitomize clean modern style so it is hard to believe that the techniques and images on these dishes are centuries old.

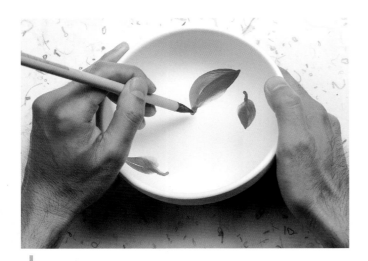

1 Plan the positions of each leaf so that the large and small leaves face in different directions. Using the *sakuyo-fude* brush, paint each leaf in two strokes, first left, then right.

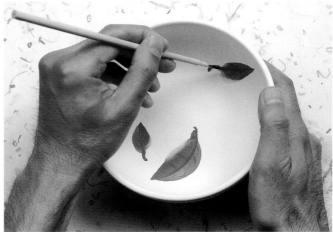

2 Use the *menso-fude* to paint the leaf veins. The lines may at first disappear into the background, but when the dish is fired, they will stand out again. Fatten the edge of the leafy stalks as if they have been naturally stripped off.

You will need

Unglazed ceramic
 bowl
Sakuyo-fude brush
Menso-fude brush
Ceramic ink
 (black)
Seal
Seal ink

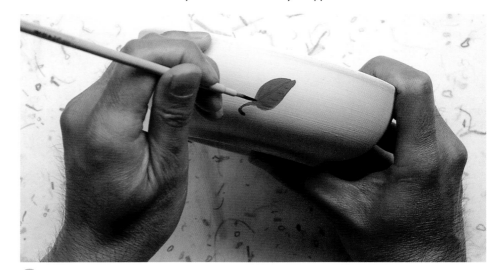

3 Paint a leaf on the outside of the bowl, trying not to paint it in vertical or horizontal direction. Finish with a seal in red ink before firing the bowls in a kiln to fix the ink.

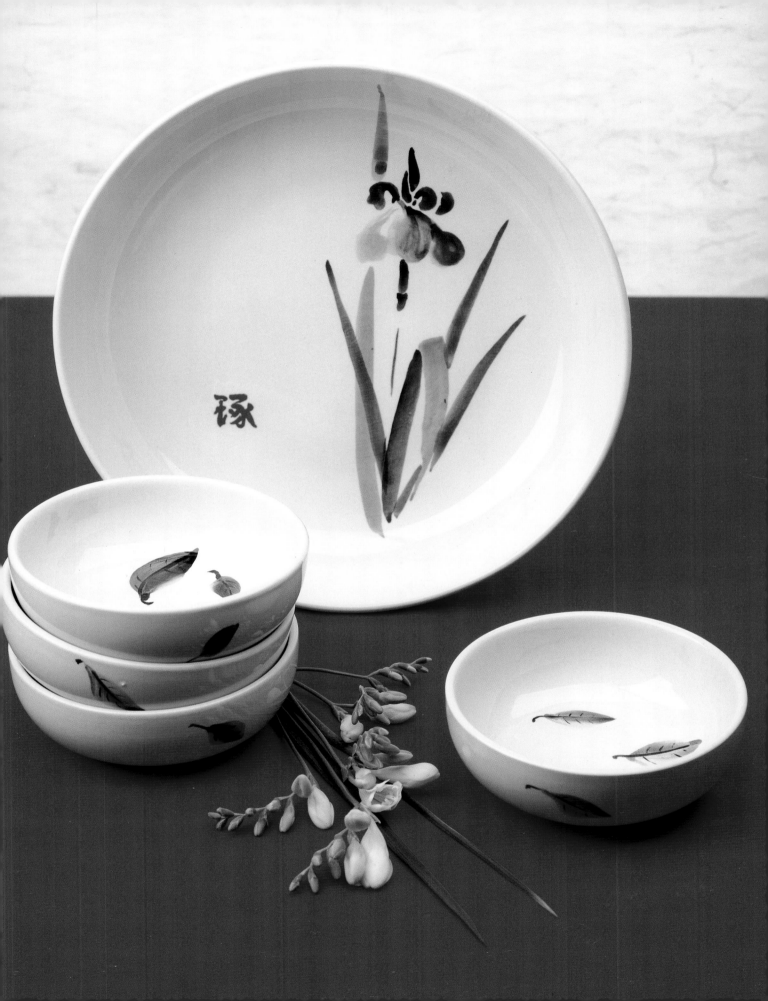

Framed *Shiki-shi*

Japan is an island country surrounded by the ocean. Fish have been one of the prominent motifs in Japan from long ago. Here, a *shiki-shi* has been decorated with a pair of carp floating serenely against the pure white of the board. The carp, capable of climbing upstream against rapid currents, is seen as a symbol of strength, courage, and patience as you make the journey through life.

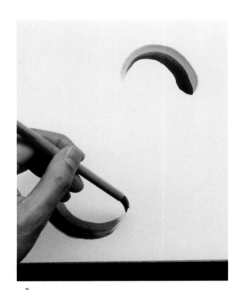

1 Paint the body using the *tsuketate-fude* brush and the *sanboku-ho* technique (see page 32). Apply medium ink to the second stroke to define the fish's shape.

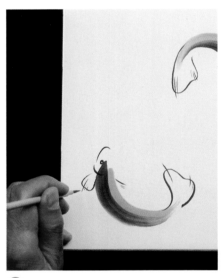

2 Prepare the dark ink, ensuring the ink consistency is thick to prevent blurring. Apply to the *menso-fude* brush and draw the head and fins of the fish.

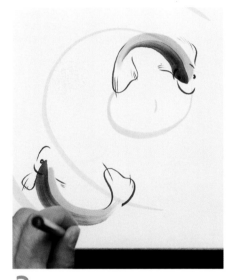

3 When dry, paint the rippling water with an upright *tsuketate-fude*, its tip loaded with light ink. Paint by moving your entire body, not just your hand.

You will need

Shiki-shi board
Black matte paper
Tsuketate-fude brush
Menso-fude brush
Sumi ink
Seal and seal ink
Ruler
Cutter
Square gauge
Double-sided adhesive tape

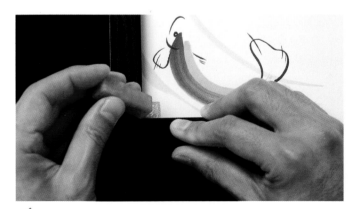

4 When finished, add your seal, using a square gauge to keep it straight. Cut out the black matte paper to the size of the frame and attach the *shiki-shi* board with double-sided adhesive tape.

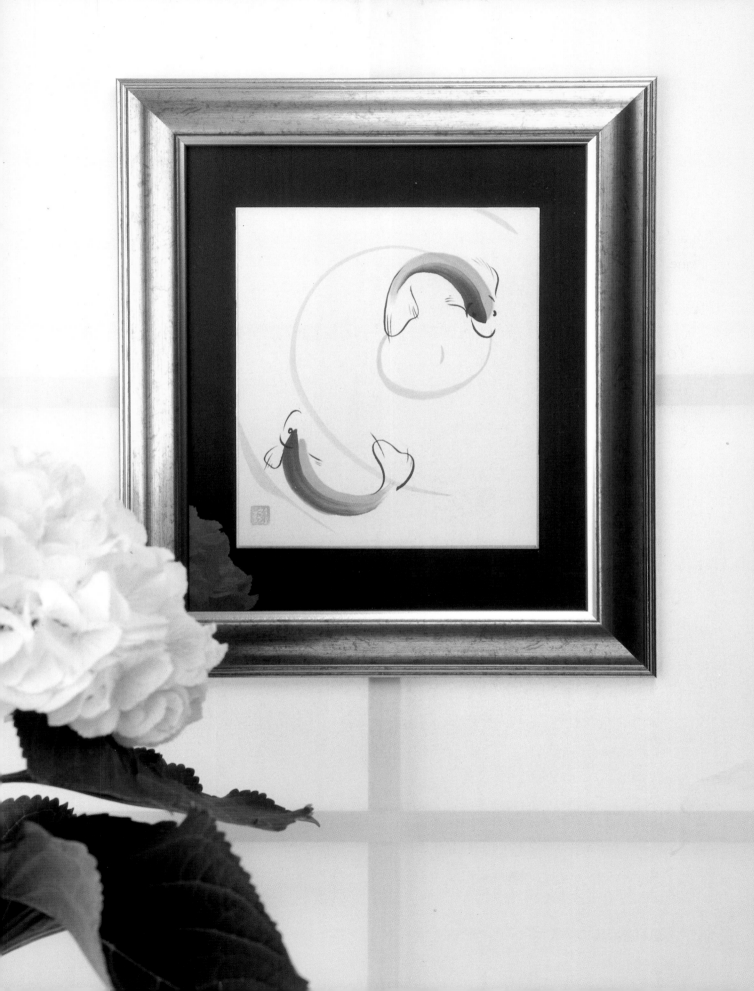

Fruits of the Vine Wine Label

The characteristics of *sumi-e* are ideal for representing the fruits of nature in all their lush appeal. Here the still-life tradition is updated with this beautiful illustration of vine fruits on a simple wine label, though painting fruit for jam pots is also ideal. As a substitute for *sake* rice wine, the Japanese also enjoy wine made from white grapes, but the artwork here is suitable for both red and white wine. Mark a special occasion by personalizing your label with a name written in Japanese script from the selection in the *Inspirations* section (see pages 124–126).

You will need

Unopened wine bottle
1 sheet *washi* paper
Sakuyo-fude brush
Sumi ink
1 sheet rayon paper
Flat board
Paintbrush
Water-based glue
Water

1 Load the *sakuyo-fude* fully with the dark ink to paint the leaves of the vine onto the *washi* paper. Make up the structure of each leaf in only two strokes using the *mokkotsu-ho* technique (see page 44).

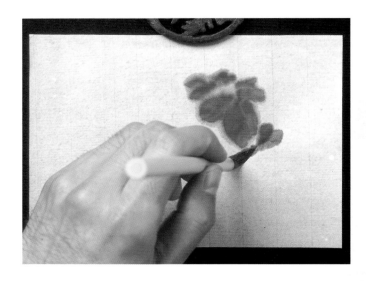

2 To give the grapes the appearance of solidity, paint those in the center of the cluster of grapes by rotating the heel of the brush to form a complete circle. Paint grapes along both edges in a half circle.

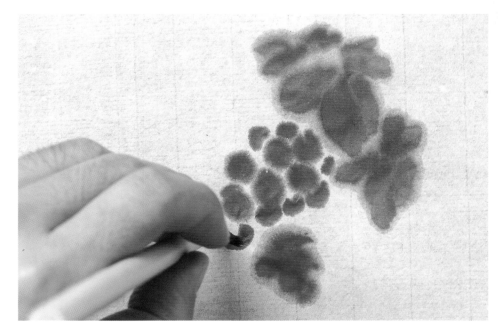

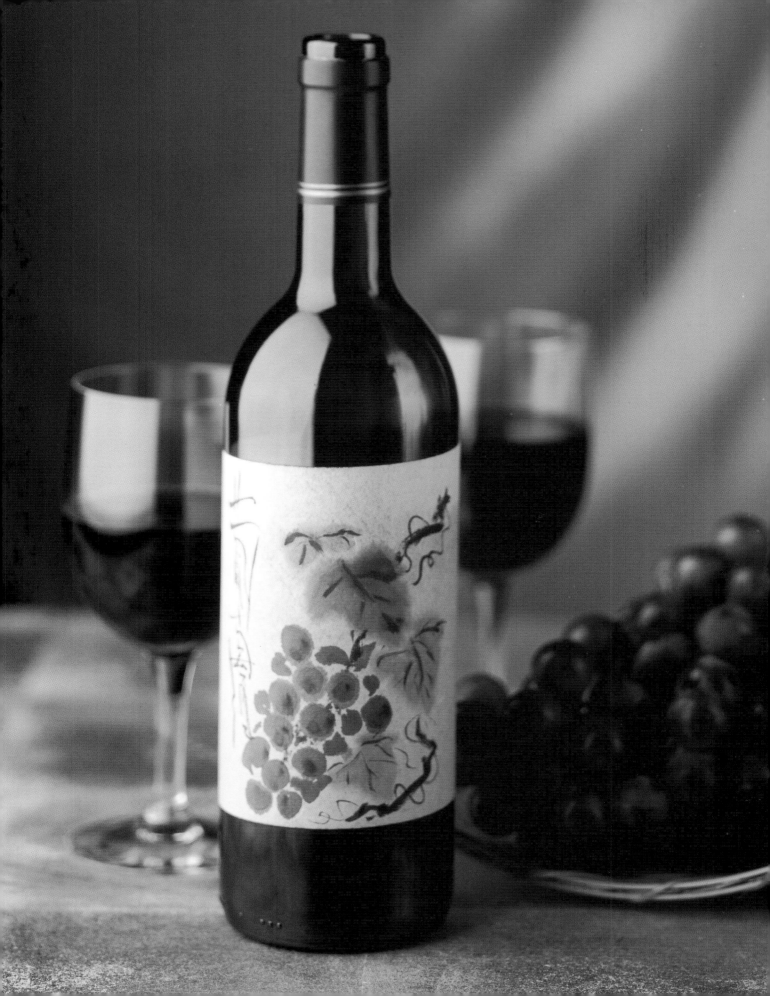

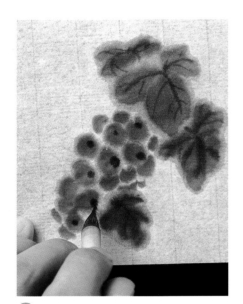

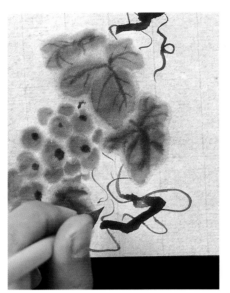

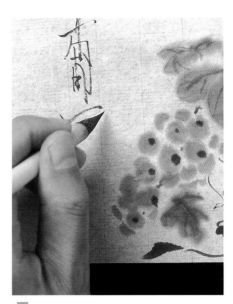

3 To make the cluster of grapes shine out from the image, draw a dark dot in the middle of every circle. To ensure the leaf veins look blurred, paint them before the leaf has dried.

4 Give a woody impression to the vine connecting the grapes and leaves by painting in dark ink using the dry brush technique, wiping the ink off the brush with a piece of tissue paper before it dries.

5 Japanese characters are written vertically. The characters in the image spell "grapes." Keep the painted label flat for a week to allow the ink to dry. If it is still damp, the ink will disperse when pasted with water during mounting.

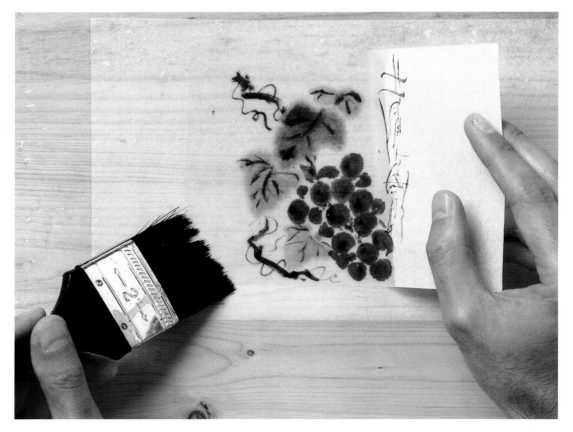

6 To mount, pour water onto a clean board and lay down a sheet of rayon paper. If this is unavailable, you can use the backing paper of self-adhesive labels. Reverse the painted label and lay it on top. Smooth down the label using a wide paintbrush and lots of water. Work very quickly as the label can easily tear.

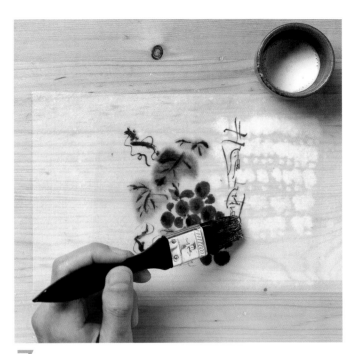

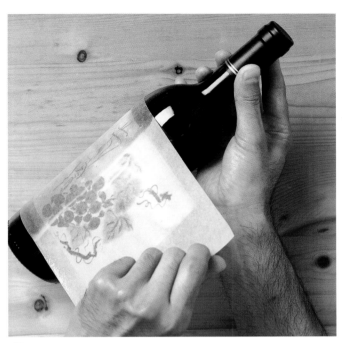

7 To apply the label to the bottle, mix a saucerful of 50 percent water and 50 percent paper glue. Apply the glue to the back of the label using gentle brushstrokes.

8 Lift the label and rayon paper from the board and wrap around the bottle. Be careful to keep it straight, as you will not be able to easily remove the label once it is in place.

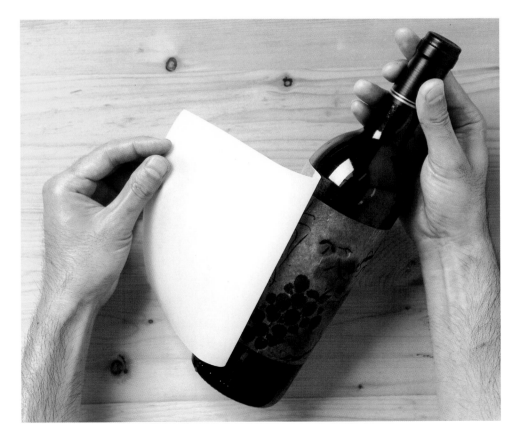

9 Peel away the rayon paper—the glue will hold the label to the bottle. If the label is still wrinkled, dip a paintbrush in water and stroke the label up and down. You will not notice the wrinkles when the label has dried.

Chopstick Holders

Chopstick holders, an important feature of a Japanese table, are both extremely easy to make and to personalize with your own individual touch. Formed from a single sheet of paper folded three times lengthwise with one end tucked up, they have a large front panel which is ideal for decorating. You can also add a small motif that mirrors the main image or place a seal on the back flap.

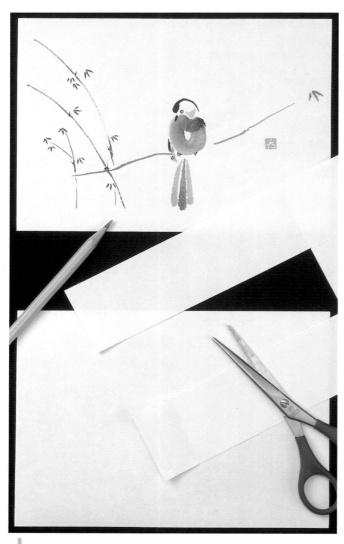

You will need

Paper
Paper scissors
Ruler
Pencil
Sakuyo-fude brush
Menso-fude brush
Sumi ink
Seal and seal ink

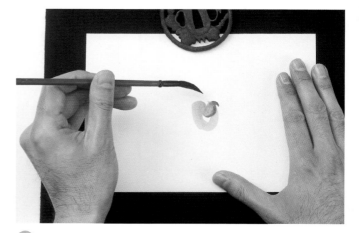

1 Make a "C"-shaped template by folding a sheet of paper in three lengthways. Open out and mark the creases. Measure the width of one column, marking that distance from one end of the sheet. Cut around the creases. Lay the template over an identical sheet and pencil in the outline of the front panel.

2 Use the *sakuyo-fude* brush to draw the body of the bird in a heart shape with a single movement. Start at the top right and work counterclockwise. In the middle of the body's top, drop the brush while it is still well-loaded with ink. Use the tip to create a dark edge to your stroke.

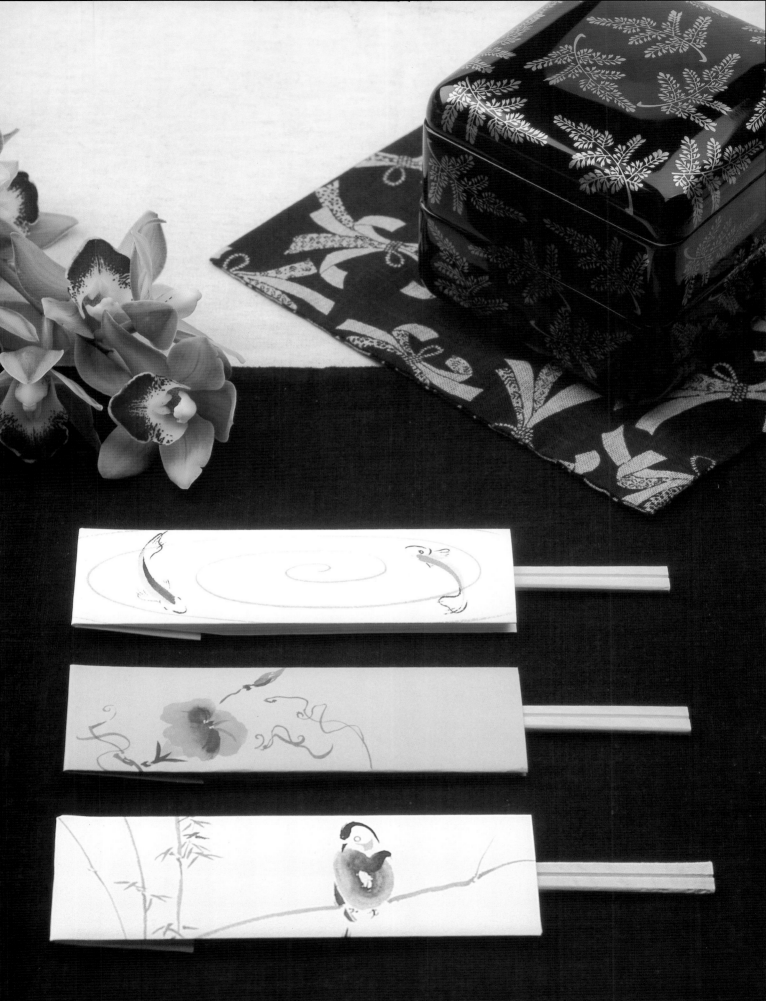

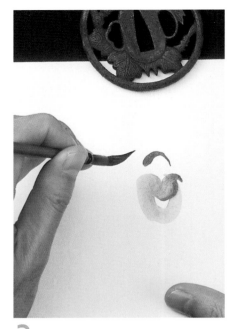

3 Use dark ink and paint the head, from a narrow point at the back to a thick forehead.

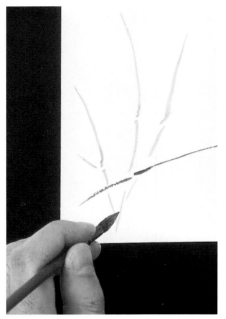

4 Paint the branches using the very tip of the brush. Ensure that the design balances the bird and that most, though not all, of the image will end up on the front panel.

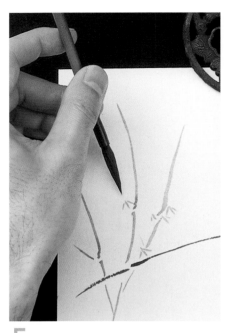

5 Paint groups of tripartite leaves, using vertical dot strokes, spread along all of the branches.

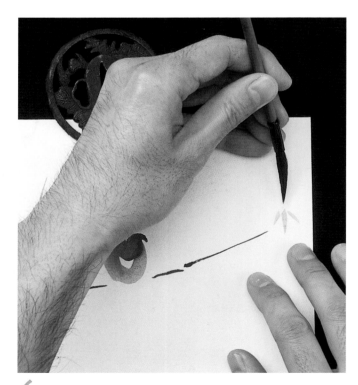

6 Add an extra set of large leaves as a motif on the section that will become the rear panel.

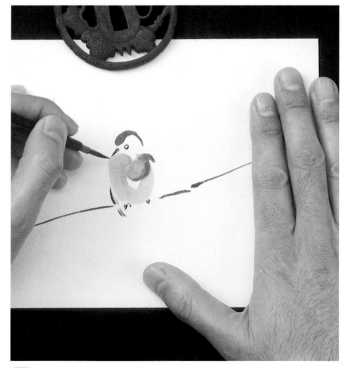

7 Use the *menso-fude* to add the bird's beak, eye, wings, and feet in dark ink with a light accent on the inside of the wing.

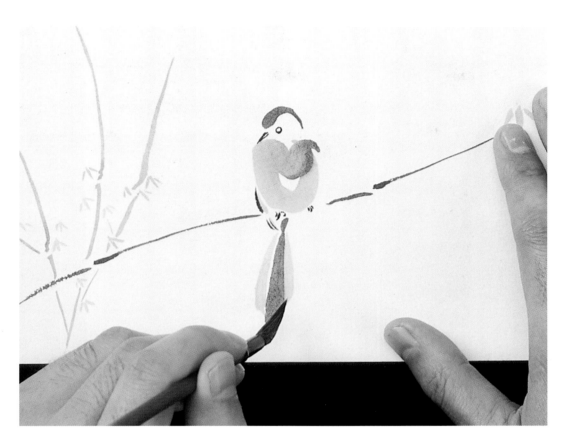

8 Use the wider brush to paint the tail. Include the lighter, outer bands of color before filling the gap with a single, darker stripe. Gradually press the brush down to flatten the hairs and widen the stroke.

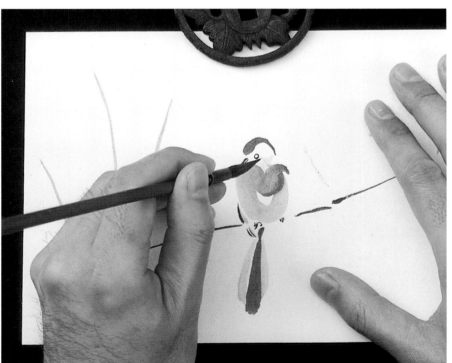

9 Add a final splash of light ink onto the neck of the bird.

10 Finish by placing your seal. Follow the pencil marks to ensure it sits on the rear panel.

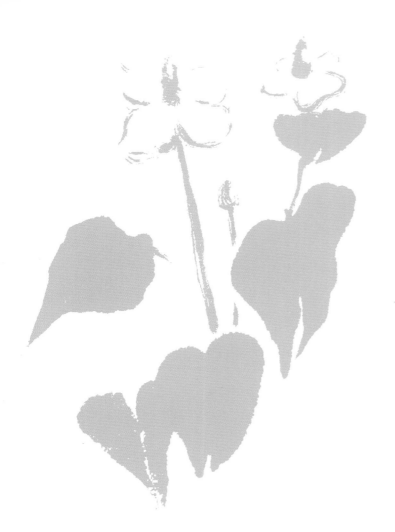

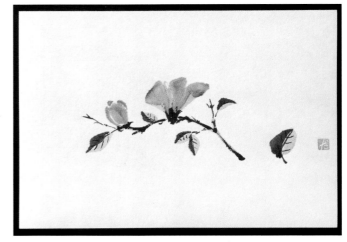

Anemone

Variations

Create a whole set of chopstick holders for a dinner party or even a lunch with friends. Mark up each sheet of paper as in Step 1 (see page 86) and check that your composition will sit in the central panel with a small motif and seal folding onto the reverse.

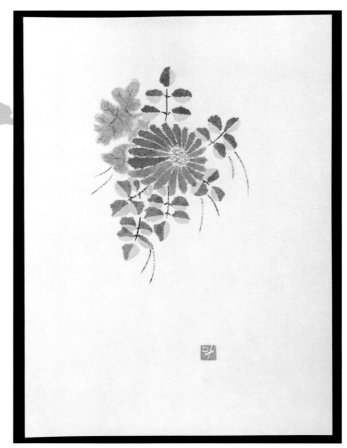

Chrysanthemum

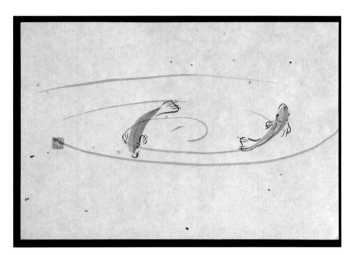

Pair of goldfish

Plum blossom

Beefsteak plant (Shiso)

Daisy

Scented Sachets

Use the sachets as original party gifts or place markers. You can create sets of them; perhaps make collections of fruit, flowers, birds, or fish; for a quirky touch, try creating a set of vegetables, or, for abstract elegance, reproduce the Japanese ocean wave patterns. For a selection of patterns, see pages 94–95.

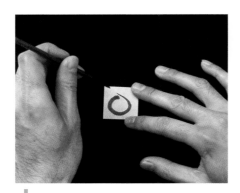

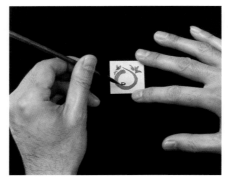

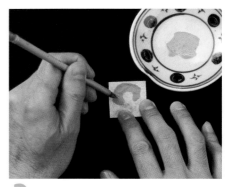

1 Cut a piece of white, textured paper into a 1½ in. (4 cm) square. With the fine *menso–fude* brush, use the illustration on page 94 to paint the outline of an orange onto the white paper in a firm stroke ending in a sharp tip.

2 Using the *menso-fude* brush, add leaves above the fruit and then the navel at its base.

3 To add color to the motif, apply ink to the underside of the pape using the *sakuyo-fude*. Mix orange watercolor paint, or colored ink, and apply to the back of the white paper with the tip of the brush. Press your thumb gently onto the topside of the paper until a patch of color seeps through. Do not press too hard or the paper may tear. Allow to dry thoroughly.

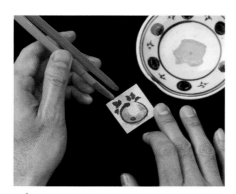

5 Cut a piece of colored, textured paper into a 1½-in (4 cm) square and bring the tweezers, sandalwood, and a fine brush to hand. Place a small amount of water-based glue into a saucer.

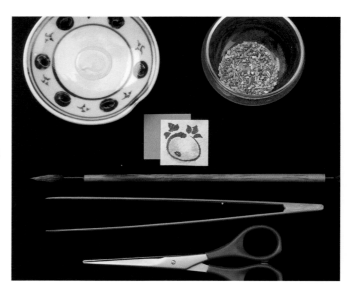

4 When dry, turn the paper back over, using the tweezers to prevent smudging the image.

6 Use a fine *menso-fude* brush to add glue around the edge of the colored paper.

7 Add a further spot of glue in the center of the paper.

8 Sprinkle some scented sandalwood chippings onto the central glue spot.

9 If you are creating a set and wish to vary the look of each sachet, trim away a corner or two from the white paper so that some of the background color comes to the fore.

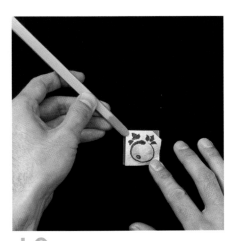

10 Use the tweezers to stick the white paper onto the colored sheet.

Alternative: Golden Sachet

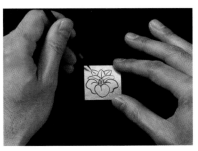

Painting onto gold paper looks beautiful, but there are some extra points to watch out for. Follow Step 1 as above, drawing the motif with a fine brush before spraying the paper with fixative to seal the ink. Finish the sachet as before. Take care not to touch the topside of the paper before painting and fixing—residue from your fingers may stop the paper from taking the ink. Gold sachets can be painted in black only.

You will need

White and colored textured paper
Paper scissors
Sakuyo-fude brush
Menso-fude brush
Sumi ink
Colored ink or watercolor paint
Water-based glue
Sandalwood, shredded pot pourri, or dried lavender

11 Finally, squeeze the two together, taking care to remove any air bubbles around the edge.

You will need

Crackle gold textured paper
Menso-fude brush
Sumi ink
Spray fixative

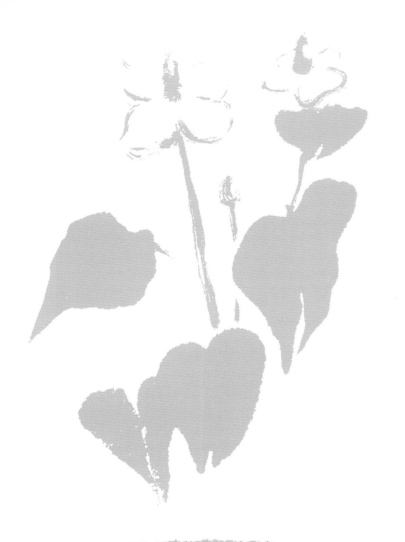

Variations

Make up entire sets of sachets, using any motifs and patterns. Add more variation by using different colored papers and inks.

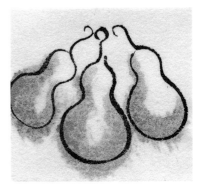

Bottle Gourd

Japanese crest (Sasarindo)

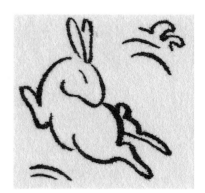

Jumping rabbit

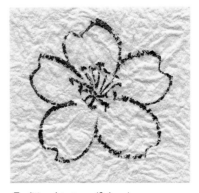

Traditional pattern (Sakura)

Japanese crest (Uraume)

Traditional pattern (Manjugiku)

Eggplant

Traditional pattern (Ryusuimomiji)

Japanese crest (Hosoge)

Dandelion

Crane

Chrysanthemum

Kaki

Traditional pattern of cloud (Kumonomaru)

Traditional pattern (Kanzesui)

Plum blossom

Camellia Lampshade

Gently lit from behind, camellias blooming across a creamy background turn this plain lampshade into a feature that would be at home in a bedroom or among the clean lines of a modern lounge. With the gentle velvety petals flowing across the shade in a diagonal, the strokes are softened using a fully loaded wet brush that produces a rich, bold, blotting effect, while a dry brush applying a minimum amount of ink creates the scratchy, narrow, and vigorous strokes of the branches. If you decide to create a pair, do not match them perfectly; their beauty lies in their individuality and natural charm.

You will need

Cloth lampshade
Thin *washi* paper
Tsuketate-fude brush
Sakuyo-fude brush
Hard pencil
Rayon paper
Paintbrushes
Scissors and paper glue
Rag

1 Mark a large piece of *washi* paper with the dimensions of the lampshade. Line up the seam of the shade with the edge of the paper and roll the shade in a complete arc across the paper marking a 1 in (2.5 cm) margin at the top and bottom with a hard pencil.

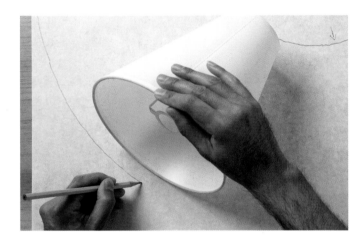

2 To create the different tones of the petals in one stroke, load the *tsuketate-fude* fully with medium ink first, and then dip the tip of the brush in dark ink. Using the *sokuhitsu-ho*, or slanted brush technique (see page 30), rotate the brush with your fingers, allowing the different shades to appear on the *washi* paper.

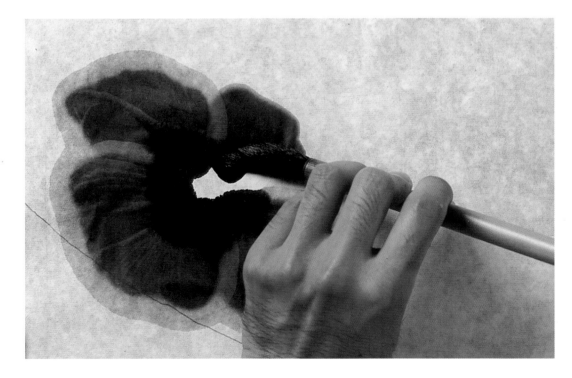

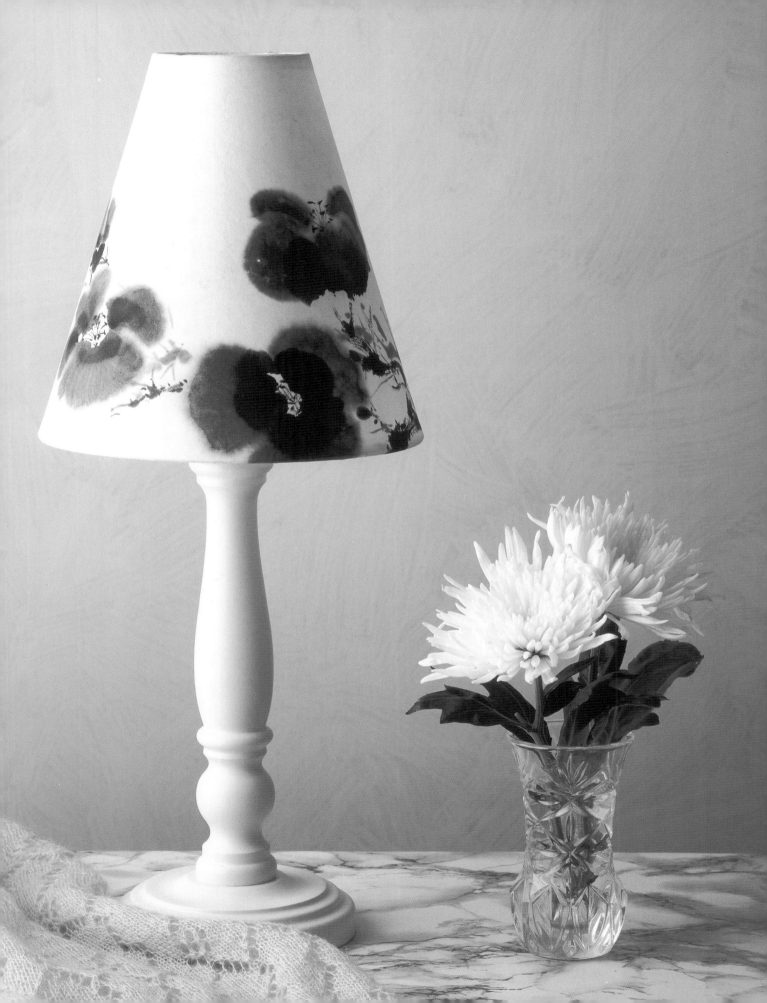

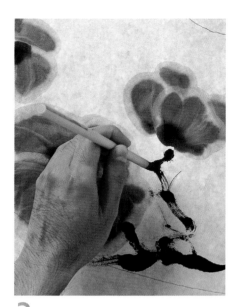

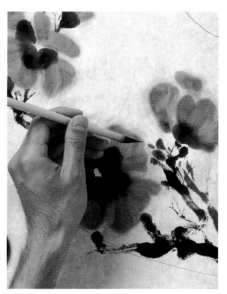

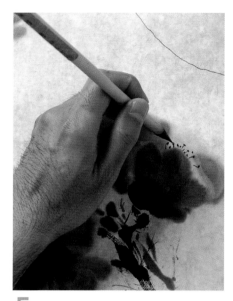

3 Paint the branches with dark ink, using the dry brush technique (see page 43). To add rhythm to the painting, hold the brush in the *chokuhitsu-ho*, or upright, position (see page 31).

4 To give the painting a three-dimensional effect, paint the branches behind with the same technique but in a lighter shade of ink.

5 To give the center of the flower a sharp impression, fill the *sakuyo-fude* with dark ink and use a rag to draw up the ink a little before using the dry brush technique to add the detail.

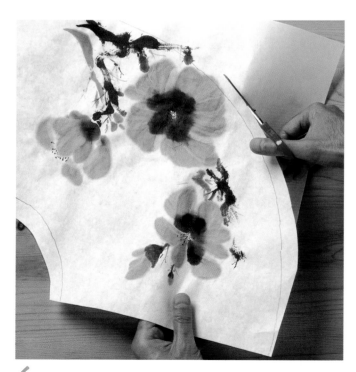

6 Leave the painting for a week after you have finished work to ensure all the ink is completely dry. Cut out the shape of the lampshade using the lines drawn in step 1.

7 To mount the painting, place a sheet of rayon paper onto a clean board and smooth it out with water. Then reverse and place the painting you have finished on top, spreading it out with a large paintbrush filled with water. (See "Mounting," page 116.)

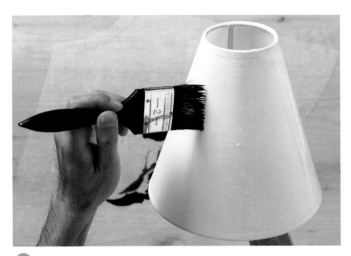

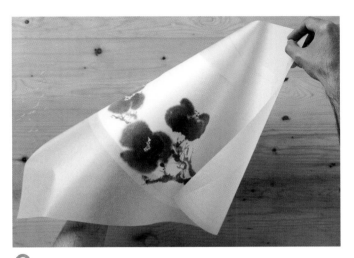

8 To fix the painting to the shade, use a paintbrush to cover the lampshade with glue. Do not dilute the glue with water and ensure the shade is completely covered, including the top and bottom edges.

9 Carefully pick both sheets of paper up from the work surface and roll them, rayon side outermost, around the lampshade. Ensure that the *washi* aligns with the shade. If it does not, gently lift both sheets away and start again.

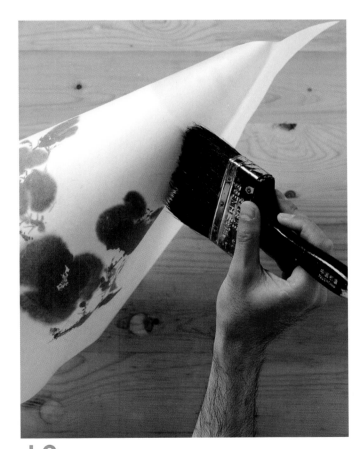

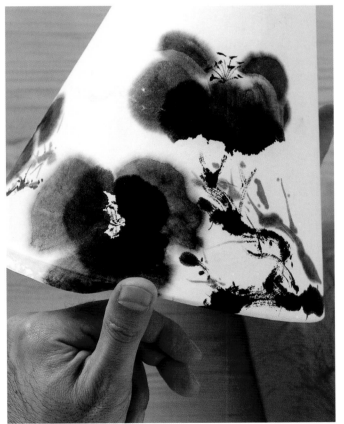

10 Using a paintbrush filled with water, spread out any wrinkles and adhere the painting to the lampshade. If air bubbles are trapped under the painting, stroke them with a wet brush to push the air out.

11 Carefully remove the rayon paper, and leave the shade to dry. When the paper is half dry, apply glue to the margins on the *washi* paper and tuck them over the top and bottom edges of the lampshade.

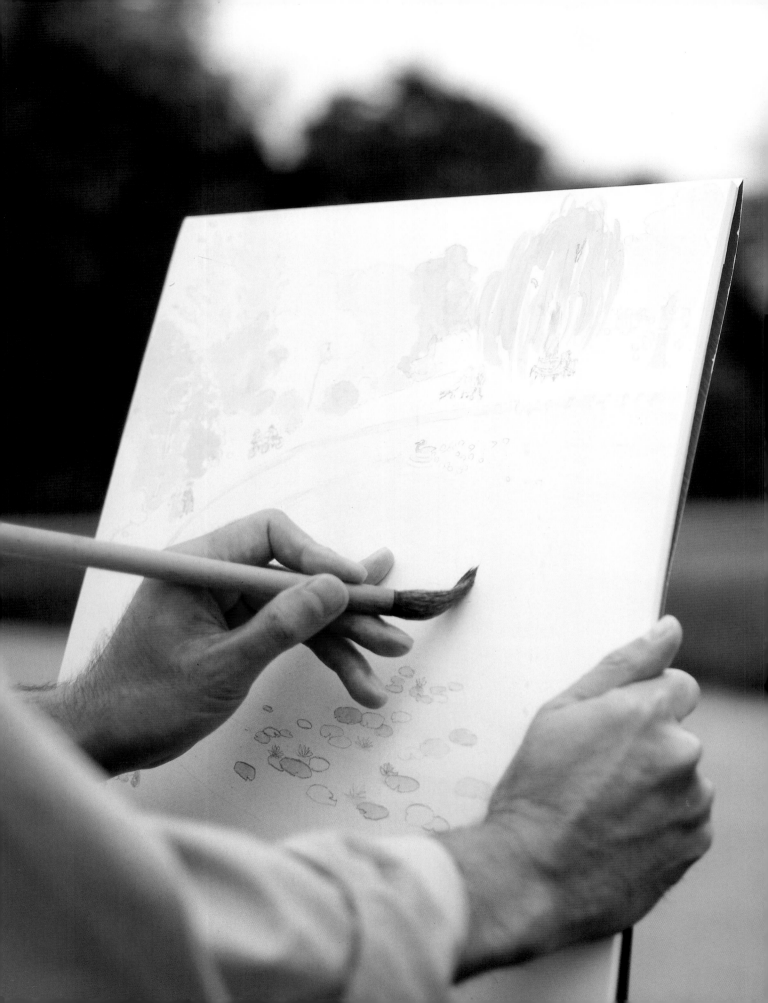

The Spirit of Nature: Open-air Sketching

Standing in the midst of beautiful nature, it feels so natural to capture the scene in *sumi-e*. Express the view with a very small palette, purifying the subject and distilling the basic components of the scene into art. Before three-dimensional perspective was introduced to Japan, distant objects were emphasized by the use of progressively lighter shades of ink. Depict in detail what is near to you, but, in the middle of the picture, extend the range of vision. Looking down from an angle above creates a perspective that is easy to paint—imagine yourself as a bird.

You will need

Cotton paper—11 x 17 in. (28 x 43 cm, A3)
Medium-hard pencil
Eraser

Sumi ink
Tsuketate-fude
Sakuyo-fude
Watercolor paint

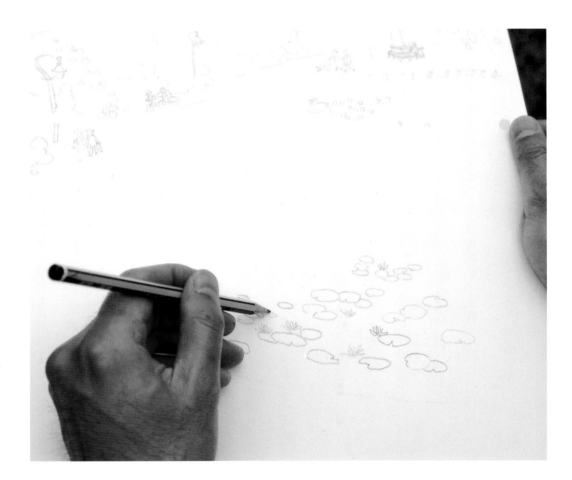

1 Make a very rough sketch on cotton paper using a medium hard (HB) pencil. Do not press too hard, or later the ink will gather in the line made on the paper. Use the pencil only to mark lightly what you want to paint.

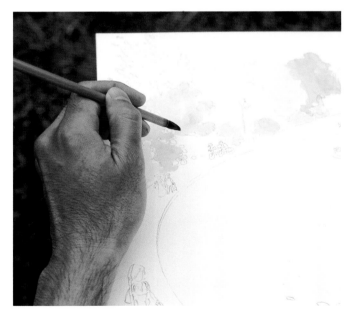

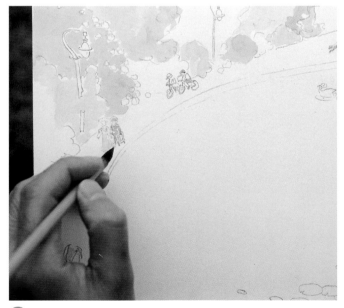

2 Consider the trees as one big mass, as if seen with half-closed eyes. Their color falls into three or four types. Use a *sakuyo-fude* to group each one without dominating the entire picture. Start with light *sumi* ink.

3 Paint the details of the walking people using *chokuhitsu-ho*, or upright, brush technique (see page 31) to enhance contrast; also add the shadow. Work slowly: remember that cotton paper takes more time to absorb ink than *washi*.

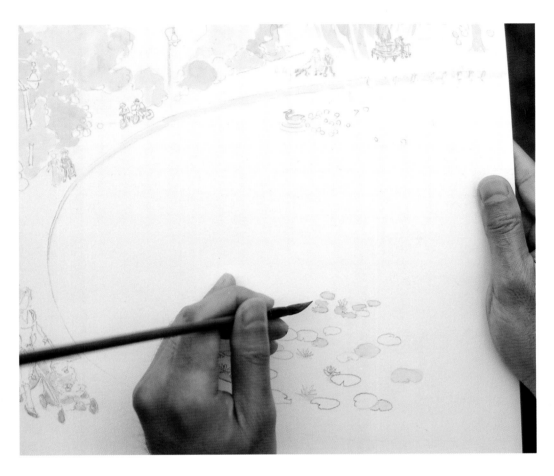

4 Paint the water lilies with light green water-color and the *sakuyo-fude* brush, imagining that you are looking down on them from above. Although open-air sketches are usually made from a single position, walk around to uncover many extra details which will make your sketches delightful.

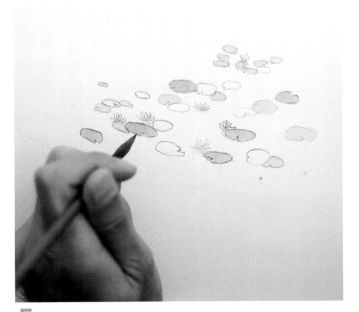

5 Depict the details of the water lilies with darker shades of *sumi* ink and watercolor paint, according to their states— whether settling under the water, floating, or appearing as young leaves. They each have a rhythm in the way they sprout.

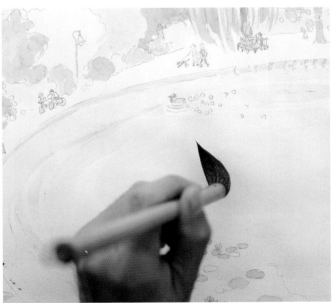

6 Add balance to the picture by detailing the pond. Use the *tsuketate-fude* in the *sokuhitsu-ho*, or slanted, brush position to add a big rise expanding from the pond's center. Paint the circle without hesitation, using all the ink loaded on the brush.

Bamboo Tablemat

In both China and Japan, for centuries bamboo has been the symbol of longevity and silent strength. The shoots and leaves can be painted myriad ways, capturing the elegant lines as they move through the seasons, eternally representing silent hope and grace. Use *washi* hardened with lacquer—it repels water, and can recover even from a complete soaking—to make a set of decorative mats.

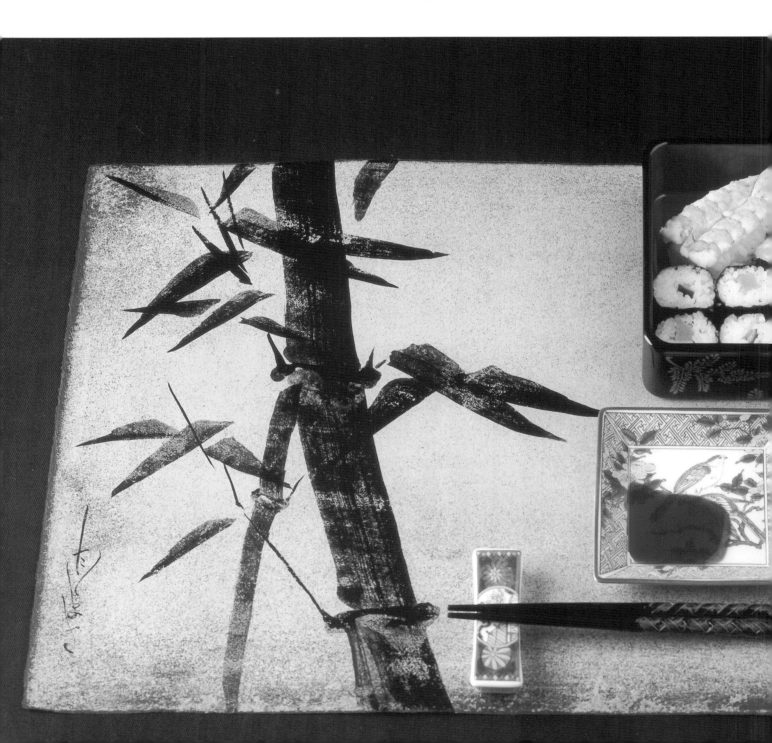

You will need

Japanese lacquered
 paper, or thick
 waterproof paper
Tsuketate-fude brush
Menso-fude brush
Sumi ink

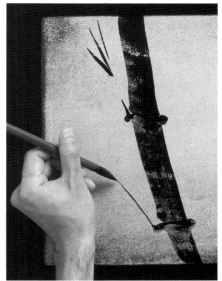

1 Use the *tsuketate-fude* to paint the first bamboo segment by segment from the bottom up (see page 44). Paint the twigs using just the tip. Work slowly to allow the ink to fix on the shiny surface.

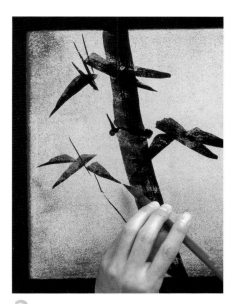

2 Paint the leaves using the *soko*, or slanted brush, technique (see page 30). Take care not to split the tips of the leaves, painting three in a set, one in the center with the other two in symmetry.

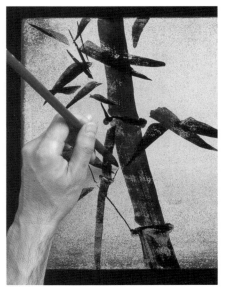

3 As it is difficult to produce color contrast on lacquered paper, give the rear bamboo branches perspective by painting them more thinly.

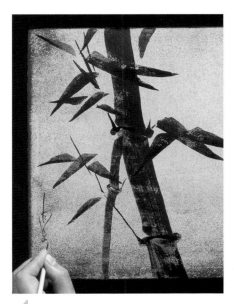

4 Sign the painting, using the *menso-fude*, in dark ink. Remember to balance your signature with the overall design.

Kite of the Dragon Warrior

Long an Eastern tradition, flying kites, or *tako*, made from light bamboo or wood over which hand-painted *washi* paper is affixed, was originally thought to have started as a plea to the gods for sunny days. Now an international pastime, kite-flying in Japan still marks annual celebrations, with huge kites flown as a part of the Children's Day festivities in the tiny village of Hoshubana. Whether decorative, or meant to fly, making the "theater of the sky" has continued for centuries, and the Japanese are still dedicated to producing kites as flights of artistic fancy as well as engineering.

You will need

20 x 18 in (50 x 45 cm) paper (very light)
Hard pencil and paper glue
Tsuketate-fude brush
Sakuyo-fude brush
Sumi ink
Gouache paint, spray mister
Paintbrush (small)
1 24–in (60-cm) stem thin bamboo, split into three widths
Cotton thread and kite string

1 On the paper, draw a rough sketch with a pencil to fill the whole area. Often, the designs such as this dragon, which look the strongest, are the ones that fly best. Try a pattern based on a "ninja," or "samurai."

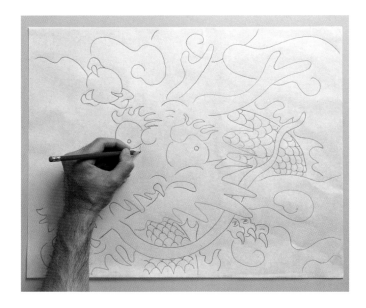

2 Paint along the lines of the sketch with *sumi* ink. First, use the *tsuketate-fude* loaded with light ink and using the *soko* slanted brush technique (see page 30) to draw the clouds. Then paint the outline of the dragon motif firmly with dark ink. Finally, use medium ink to draw the dragon's whiskers and mouth.

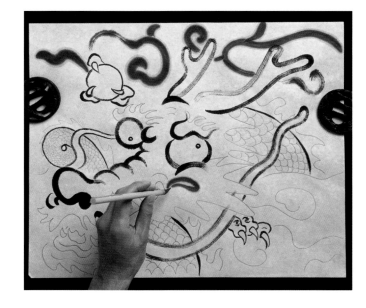

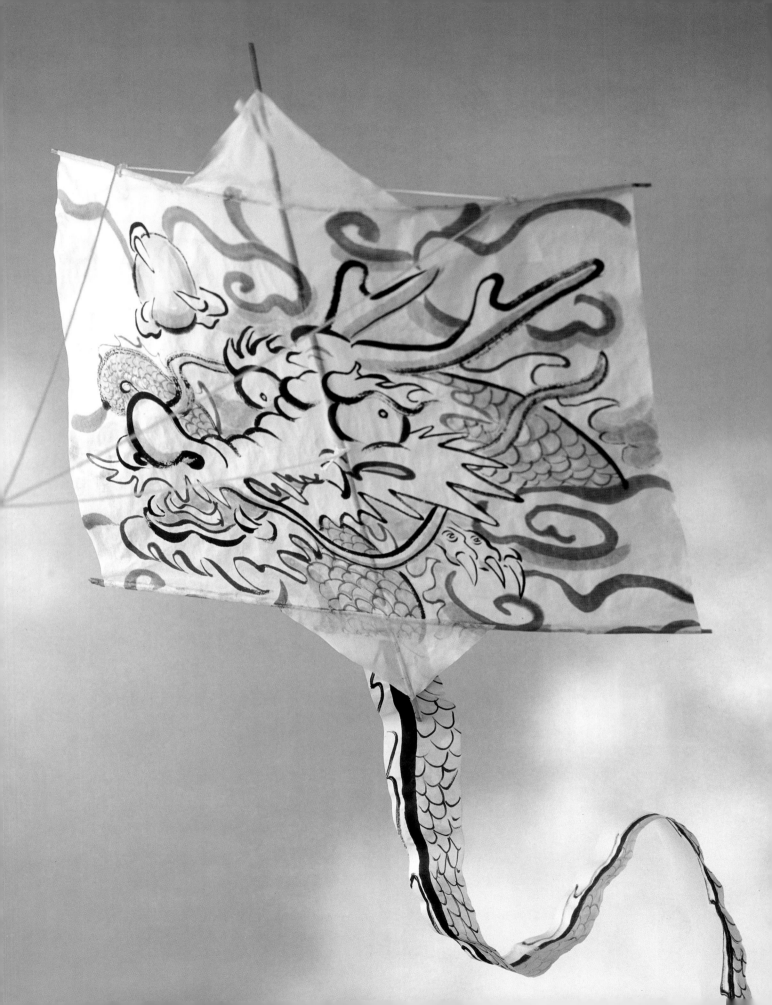

3 When you have completed the ink lines and they have dried, turn over the kite to color it up. Using a *sakuyo-fude* brush, paint with gouache, letting the color seep through from the reverse. This way, the ink lines emerge and stand out.

4 Make the frame from three equal lengths of split bamboo tied together in a double cruciform shape with cotton thread, and sized so that the top and bottom edges of the paper overlap the spars by ½ in. (1 cm). Coat them with glue to fix to the paper.

5 Apply the painting to the bamboo frame, allowing for the vertical margins of about ½ in. (1 cm) at top and bottom. Be careful not to bend the bamboo frame out of shape. Fix triangle-shaped reinforcing paper to the head and tail of the kite.

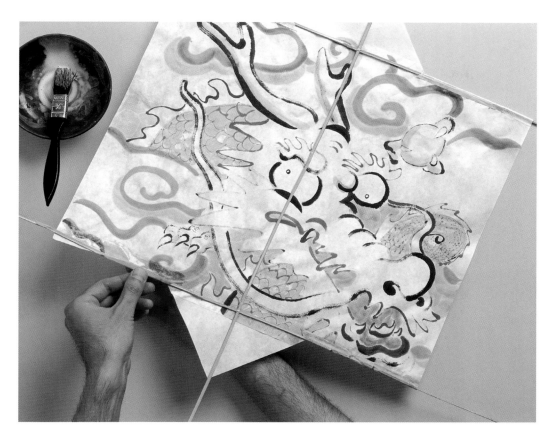

6 Fold the top and bottom edges of the picture over the spars, scoring along the edges of the triangles. It is best to fold when the glue is half dry. If the glue has dried thoroughly, mist the picture with water to make this easier.

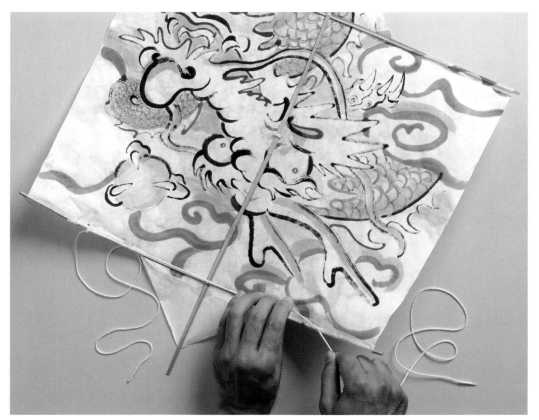

7 Tie kite string to both sides of the top spar about one-third of the way from both edges of the upper frame. To keep the tension on the kite, bend the spar slightly. Tie a third string to the central spine of the kite, approximately one-third of the way from the bottom, and reinforce it with a rectangular piece of paper glued over the string. To make the kite balanced in flight, even out the three strings and grasp them together in the middle before tying them to the main length of kite string.

Silken Iris Wrap

Used in both the East and the West as a symbol of perfection and love, here a delicate iris sweeps elegantly across a fine sheet of translucent silk. Images of nature communicate philosophical ideas that are key principles of *sumi-e*. In the East this beautiful bloom suggests maturity and the reaching of a personal peak of self-development. I have created the iris in black, as a wall-hanging, and in a very intense blue ink that bleeds like watercolor across the wrap version.

1 To prepare the silk for *sumi-e*, soak it in the water–milk mix. If you do not want the ink to disperse very much, use a little more milk.

2 Wring the fabric lightly, stretch it out and dry it for about a day. Do not leave it for more than three days or the effect of the soaking will be lost.

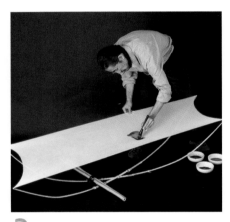

3 Prepare different strengths of *sumi* ink, mixing it with milk to make lighter shades. Rub and brush the fabric just before painting.

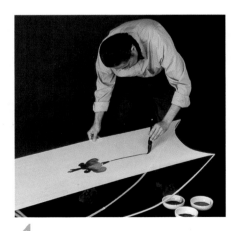

4 Use the flower painting technique (see pp. 48–49) with a thick *tsuketate-fude*. Paint a simple but bold picture which will show strong contrasts.

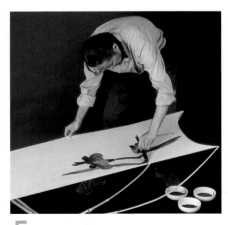

5 Silk absorbs ink slowly so allow space in your layout and keep the fabric horizontal. Ink lightens as it dries, so use widely contrasting dark and light shades.

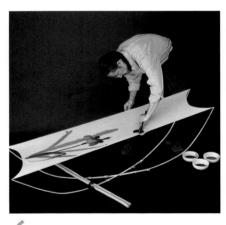

6 Paint the iris again, moving outward. Allow to dry. To fix the ink, fold and wrap the silk carefully in plain paper tied with string. Steam it in a bamboo steamer for an hour. Remove, unfold, and allow to dry.

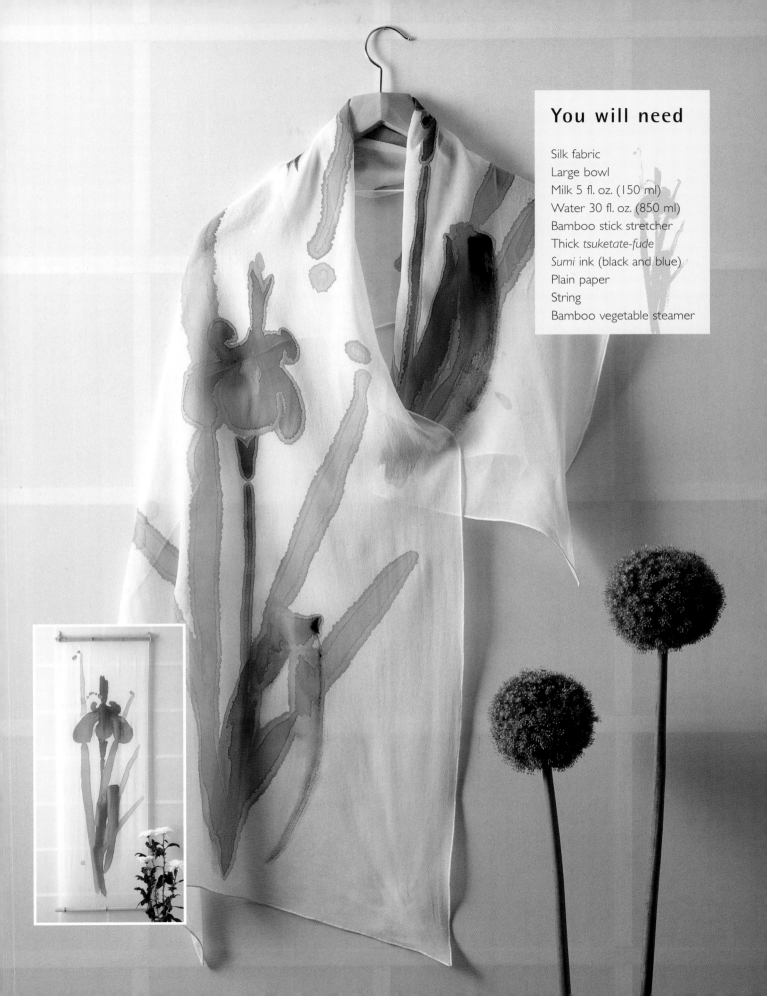

You will need

Silk fabric
Large bowl
Milk 5 fl. oz. (150 ml)
Water 30 fl. oz. (850 ml)
Bamboo stick stretcher
Thick *tsuketate-fude*
Sumi ink (black and blue)
Plain paper
String
Bamboo vegetable steamer

Making a Bamboo Brush

Sumi-e brushes do not have to be bought—using just one stem of bamboo, you can create your own durable painting tool. It makes the rough strokes unachievable with a more usual *sumi-e* brush, creating the textured, scratched effect that can be used to paint large still-lifes, or fruits and vegetables. Ideal for use when traveling or sketching landscapes, the brush is sturdy and waterproof.

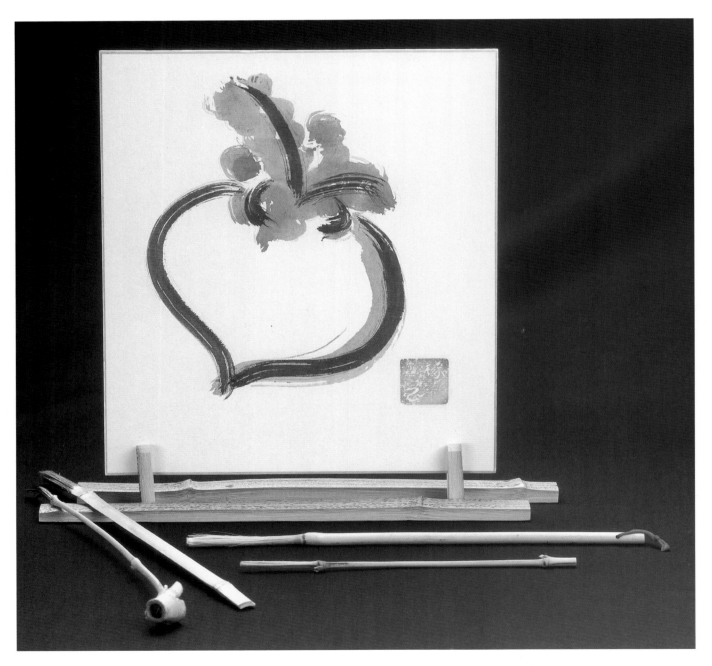

1 Wearing protective gloves, first cut the bamboo stick about 2 in (5 cm) on from a nodule, making this part the bristle end. Then cut the other end of the bamboo, making the stem of the brush overlong—the bristles will shorten when hammered.

2 Use a craft knife to shape the end that will become the bristles. Then smooth the grip of the bamboo stick by cutting away the joints in the stalk.

3 Use a stiff wire brush to smooth the stem. Place the bristle end in a small pan of boiling water, letting it stand until the bamboo fibers loosen after a few minutes.

4 After the fibres have loosened, lightly hammer this end with a mallet many times against a rock or hard surface. Repeat the procedure of boiling and hammering as necessary until all the fibers have separated. When the bristles are of a fine consistency, lightly hammer them flat.

You will need

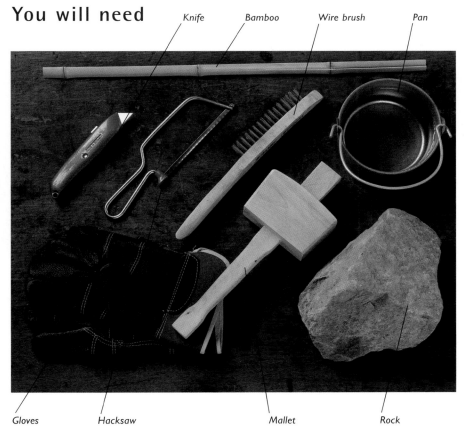

Knife Bamboo Wire brush Pan

Gloves Hacksaw Mallet Rock

Making a Seal

Sealing your work with your signature is a deeply personal addition to your painting. The authentic finishing touch, placing the seal in scarlet ink makes a bright contrast to the black strokes of your picture and gives it an important balancing effect. Seal-carving is an art in itself. Various hard materials including stone, wood, and horn are used, but you can choose any character style you like, or even use abstract designs. I usually choose a favorite character in my name, designing and carving it myself.

1 Smooth the surface of the stone by placing a piece of sandpaper on a flat, hard surface. Keeping it upright, move the stone around the sandpaper in a figure 8.

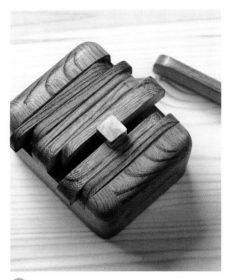

2 Fix the stone in a small vise. There is no need to use a larger tool as you will be constantly rotating the seal around as the motif is carved.

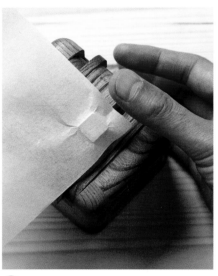

3 Place a piece of thin paper on the stone and make an outline around the edge of the seal by creasing the paper with your thumb.

You will need

1/2-in. (1.25-cm) square block
 of soap stone or wood,
 2 in. (5 cm) high
Fine sandpaper
Vise
Thin paper and seal ink
Medium-hard pencil
Scissors and glue
Narrow engraving knife or
 chisel

4 Draw the design of your seal within the outline of the creases. You can design anything you like, perhaps using an initial of your name, your favorite word, or a small image.

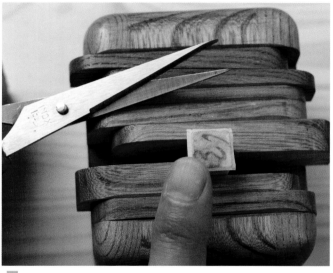

5 Cut your paper about ⅛ in. (3 mm) larger than the outline you have made. Remembering to reverse the paper, stick it onto the surface of the stone with glue.

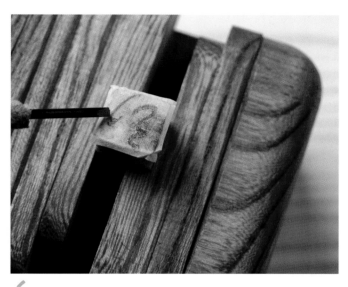

6 When the glue is dry, mark the stone through the paper along the line of your design in dots with the tip of an engraving knife or chisel.

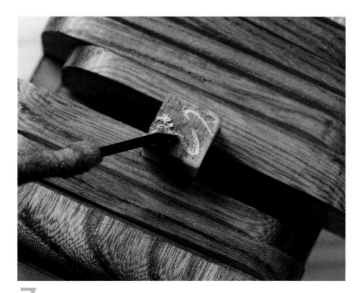

7 Remove the paper and engrave along the inner side of the dotted line. Rotate the vise to keep the angle, direction, and pressure on the knife constant, keeping the surface stable.

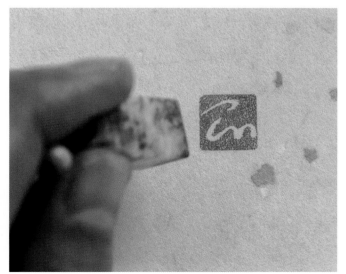

8 Do not rush the carving, or you may apply too much pressure, chipping the stone. Try printing the seal several times as you work to make sure the lines are not too weak.

Mounting

Washi has a tendency to wrinkle after it has been painted on, so to be displayed it must be stretched and mounted on durable paper such as mulberry *kozo* paper or made into a folding screen or hanging scroll. Mounting also protects the painting. Leave a new painting for about a week before mounting, or the *sumi* color will be swept away with water.

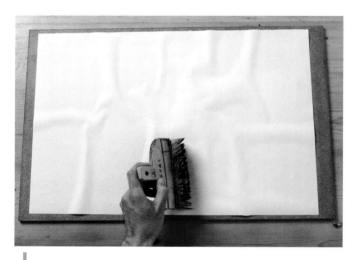

1 Wet both sides of the white or ivory backing paper: using a wet brush, spreading the water over the entire surface of the paper.

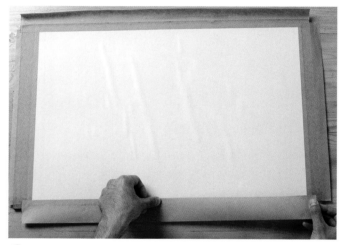

2 Spread the backing paper from step 1 onto the board. Tape the four corners with self-adhesive paper tape.

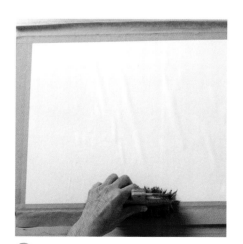

3 As the backing paper begins to dry, it shrinks rapidly. Keep the paper attached tightly to the board by stroking the tape with a paintbrush.

4 When the tape is half dry, tuck it down. Do not pull the tape, or it may peel off from the backing paper. Let it dry thoroughly for a full day.

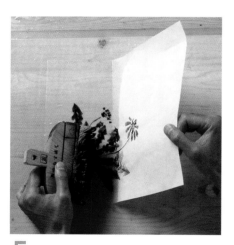

5 Wet and smooth the rayon paper on the other board. Turn over the painting and spread it over the rayon paper, flattening with a wet paintbrush. Smooth out any wrinkles.

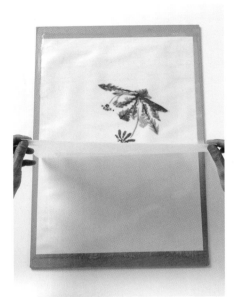

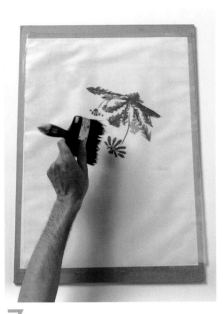

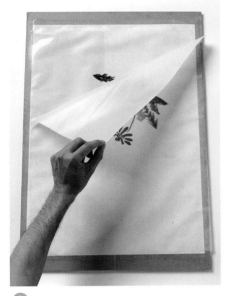

6 Mix 50 percent glue and 50 percent water and spread it over the first board. Carefully remove the painting and rayon paper together from the second board.

7 Turn them over and gently place on the backing paper. Smooth out the rayon paper with a dry paintbrush to sweep out any air and water.

8 Using a rag, gently wipe off excess water and glue and remove the rayon paper as shown. Small wrinkles will fade away when the paper is dry.

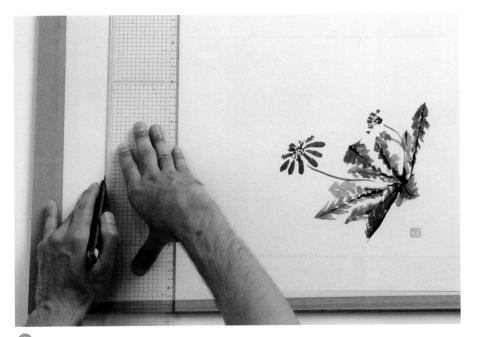

You will need

Backing paper, 1 in (2.5 cm) larger all round than painting
2 boards, 1 in (2.5 cm) larger all round than backing paper
3 large 3-in. (10 cm) brushes
Rayon paper
Self-adhesive tape
Paper glue and water
Rag
Ruler and paper cutter

9 Adjust the placement of the artwork over the backing paper. Placing the motif as the center, measure the length and breadth and cut around the edges.

一雀の子

そこのけそこのけ

お馬が通る

茶翁句

Inspirations

Be inspired by the *haiga* on the following pages, the artform that combines *sumi-e* images with the *haiku*, one of the most important forms of traditional Japanese poetry.

Originally, only images with a seasonal relationship to the *haiku* could be used to make up a *haiga*. However, nowadays the *sumi-e* you create is there to echo and enhance the meaning of the *haiku*, amplifying the feeling of the words, and providing a beautiful artwork of poetry and painting upon which you can meditate. You can enjoy creating *haiga* by using the expressive tones of color in the *sumi*, the beauty of the white space, and the placement of the calligraphy and seal.

Also included are 100 of the most popular Western names in *hiragana* script with which you can dedicate your work to family and friends.

Haiga: Wisdom of the Spirit

Uniquely Japanese, the *haiga* is a simple combination of *sumi-e* painting with a *haiku* poem—the 17-syllable Japanese poetry form that glorifies nature and the seasons. To be initiated into the world of *haiga*, work on expressing your most complex feelings through *sumi-e*, the art of "simplicity of expression." Create your own *haiku*, or perhaps use one of the well-known ones here, to accompany a painting that symbolizes one of the seasons to create a *haiga* of your own. Be inspired by the natural world, and by *haiga*, and pursue your freedom of expression with an unlimited mind.

As I eat a persimmon
The bell starts ringing
At Horyuji.
Masaoka Shiki

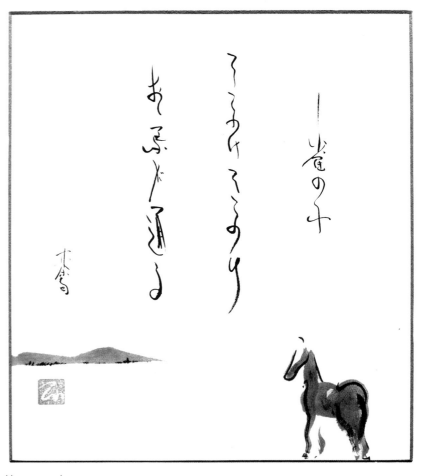

Hey, sparrow!
Out of the way—
The horse is coming.
Kobayashi Issa

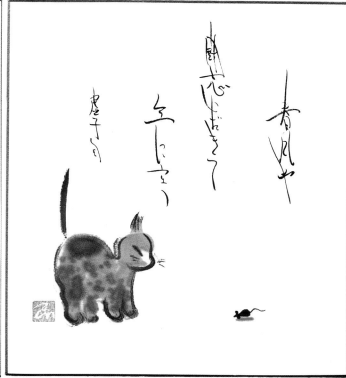

A hundred camellia flowers
Swinging in the early spring
Are my favorites.
Takahama Kyoshi

Spring breeze!
On the hill I firmly stand
With great resolve.
Takahama Kyoshi

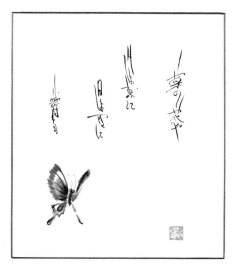

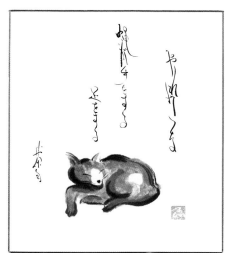

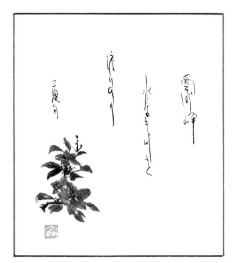

Rape-seed flowers;
The moon in the east
And the sun in the west.
Yosa Buson

Don't kill that fly!
Look—it's wringing its hands,
Wringing its feet.
Kobayashi Issa

Among the gigantic columns of clouds,
I imagine myself crossing
Over the dry river.
Masaoka Shiki

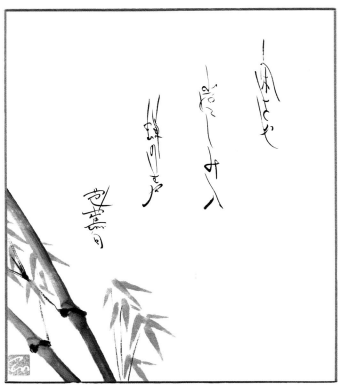

A cicada shell;
It sang itself
Utterly away.
Matsuo Basho

Winter wind
Blow not so strong
Rain cannot reach the ground.
Mukai Kyorai.

Yes, Spring has come
This morning a hill
Is shrouded in mist.
Matsuo Basho

East or west
Wherever I go
Autumn wind makes me somewhat lonely.
Matsuo Basho

Strongly, strongly
The sun is relentless
Through the Fall wind.
Matsuo Basho

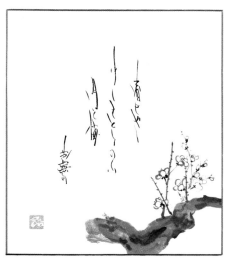

It is becoming
Springlike; See
The moon and plum.
Matsuo Basho

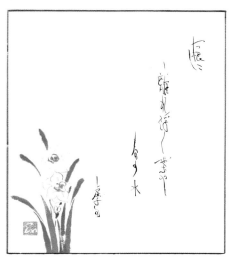

Spring water! Green leaves
Float joyful and faraway
From a mother root.
Takahama Kyoshi

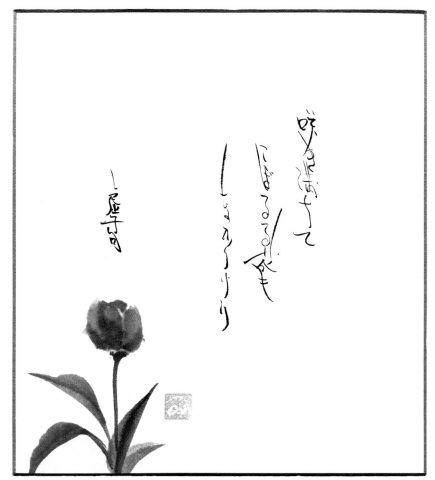

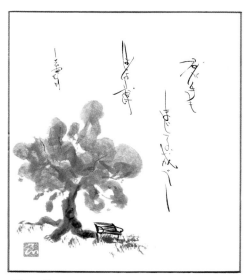

Cherry flowers
In full blossom
None is falling to the ground.
Takahama Kyoshi

My friend is bidding me farewell
Across the autumn field of pampas grass
Waving his hand forever.
Mukai Kyorai

100 Western Names

Over the following pages, written in *hiragana* characters, are 50 each of the most popular male and female names for you to personalize your work.

MALE

まいける	じゃこぶ	じょしゅあ	ましゅう	あんどりゅう	あんそにい	くりすとふぁ	だにえる	いさん	じょせふ
Michael	Jacob	Joshua	Matthew	Andrew	Anthony	Christopher	Daniel	Ethan	Joseph

ういりあむ	たいらあ	でいびっど	にこらす	らいあん	あれくさんだあ	じえむず	じょん	でぃらん	ざっかりい
William	Tyler	David	Nicholas	Ryan	Alexander	James	John	Dylan	Zachary

くりすちゃん	さみゅえる	じょなさん	ぶらんどん	べんじゃみん	じゃすてぃん	ろうがん	ほぜ	ねえさん	がぶりいえる
Christian	Samuel	Jonathan	Brandon	Benjamin	Justin	Logan	Jose	Nathan	Gabriel

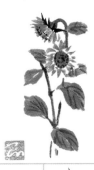

	
Robert	ろばあと
Caleb	けぇれぶ
Austin	おぅすてぃん
Noah	のあ
Kevin	けびん
Thomas	とぉます
Elijah	えらぃじゃ
Jordan	じょぉだん
Aidan	えぃでん
Cameron	きゃめろん
Jason	じぇぃそん
Hunter	はんたあ
Angel	えんじぇる
Connor	こなあ
Evan	えゔぁん
Isaiah	あぃざや
Aaron	あぁろん
Isaac	あぃざっく
Luke	るぅく
Jack	じゃっく

FEMALE

	
Emily	えみりぃ
Emma	えま
Olivia	おりびあ
Hannah	はな
Madison	までぃそん
Abigail	あびげぃる
Alexis	あれくしす
Samantha	さまんさ
Elizabeth	えりぎべす
Ashley	あしゅれぃ

Lauren	*Alyssa*	*Grace*	*Sarah*	*Isabella*	*Kayla*	*Brianna*	*Jessica*	*Taylor*	*Sophia*
Anna	*Victoria*	*Sydney*	*Chloe*	*Natalie*	*Megan*	*Morgan*	*Rachel*	*Jasmine*	*Hailey*
Julia	*Kaitlyn*	*Jennifer*	*Haley*	*Mia*	*Katherine*	*Destiny*	*Alexandra*	*Maria*	*Nicole*
Ava	*Savannah*	*Brooke*	*Ella*	*Allison*	*Mackenzie*	*Paige*	*Stephanie*	*Kylie*	*Jordan*

Acknowledgments

My special thanks to Yukiko Tagawa for translating my knotted draft; to Chizuko Tokuno for much useful advice; to Natsuko Watanabe, Akemi and Yoko Tsutsumi, Megumu and Masumi Ishiguro, Kazuo Arai, Yoshinao Sugihara, Simon Wright, Christine Williams, and Philip King for sincere cooperation. Thanks also to Georgina Harris, Cindy Richards, and Robin Gurdon for editing; to Geoff Dann for taking photos; to Ian Midson for designing this book; to Sayuri Namiki Megumi, Keisaku Wakatsuki, and my parents at home in Japan for their continued support; and to my sumi-e and spiritual master, Atsuro Nanba, who has already passed away.

I also thank the readers of this book who became interested in Japanese sumi-e and Japanese traditional art; and all those who were involved in publishing this book. My biggest thanks go, as usual, to my wife Mari for her continued encouragement and always useful suggestions and comments.

Index